JOHN PELLEW
PAINTS
WATERCOLORS

JOHN PELLEW PAINTS WATERCOLORS

BY JOHN C. PELLEW, N.A., A.W.S.

WATSON-GUPTILL PUBLICATIONS/NEW YORK
PITMAN PUBLISHING/LONDON

Copyright© 1979 by Watson-Guptill Publications

First published 1979 in the United States and Canada by Watson-Guptill Publications,
a division of Billboard Publications, Inc.,
1515 Broadway, New York, N.Y. 10036

Published in Great Britain by Pitman Publishing Ltd.,
39 Parker Street, London WC2B 5PB
ISBN 0-273-01368-8

Library of Congress Cataloging in Publication Data
Pellew, John C., 1903-
 John Pellew paints watercolors.
 Includes index.
 1. Water-color painting—Technique. I. Title.
ND2420.B44 751.4'22 78-23771
ISBN 0-8230-2564-0

Manufactured in U.S.A.

First Printing, 1979

*To the memory of my mother
for her love and encouragement
through the early years.*

ACKNOWLEDGMENTS

I wish to thank Donald Holden, Watson-Guptill Editorial Director, Marsha Melnick and Dot Spencer for their editorial expertise. I am also grateful to my wife Elsie for the many hours spent in preparation of the manuscript and to George Kaestner and John Dembeck for their valuable help with the photography.

CONTENTS

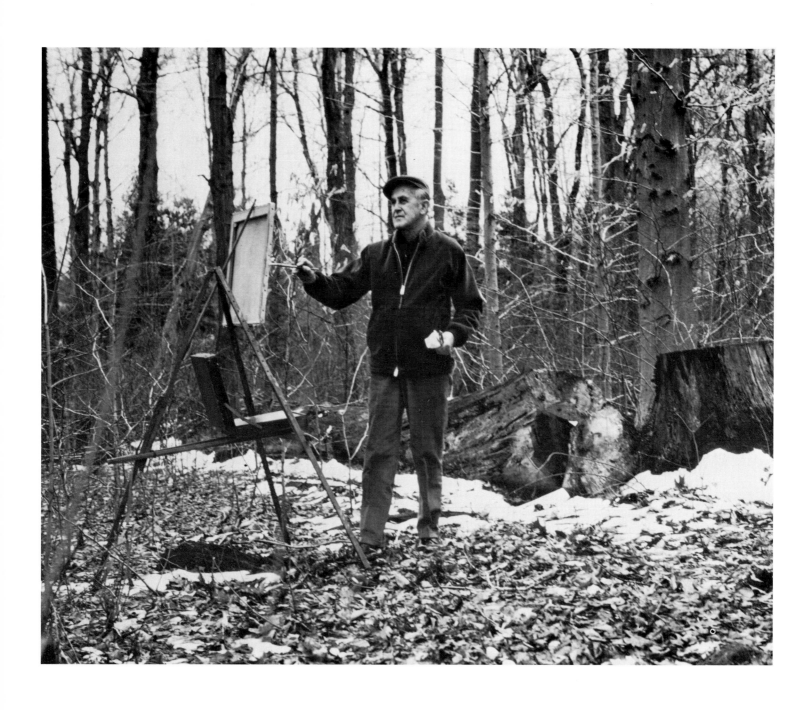

PERSONAL HISTORY

I was born in Cornwall, England, where I became aware of artists at an early age. Since the early 1800s the fishing villages of Cornwall have been popular with outdoor painters who have found the light of the Land's End peninsula more to their liking than that of the counties farther north.

Two of the first to settle in Newlyn, a village on the cliff, a mile along the beach from my hometown of Penzance, were Walter Langley and Stanhope Forbes. They attracted others and later formed what became known as the "Newlyn School." Forbes had been a student of Bastien-Lepage, the leader of the *Plein-air* movement in France, and the Newlyn painters carried on his teachings in Cornwall. They posed their models outdoors, painting the fishermen, their womenfolk, children, and old people at work, at play, and at rest.

As a child, I watched, from a distance, these men at their canvases—and no doubt that's when the desire to become an artist was born in me. All art colonies have their share of good and bad painters, and Newlyn was no exception. Stanhope Forbes and Walter Langley were two of the best. Forbes became the leader of the group and established a school in Newlyn that lasted many years and attracted students from England, Canada, and the United States.

As a teenager, my mother had posed in Langley's studio. Thirty-three years later I rented that studio from his widow and painted on the same easel her husband used to paint a beautiful girl, called Katy Jeffery, who became my mother.

There are still artists in Newlyn today. It has a fine gallery and an art society. However, at the turn of the century it was one of England's most important art colonies. There must have been great excitement there when sending-in-day for the Royal Academy Exhibition in London came around.

Some of the most popular pictures of the period, which now hang in museums in all parts of what used to be called the British Empire, were painted in Newlyn—mostly story-telling pictures to be sure, but painted with a great love for the craft and with great skill.

In the Tate Gallery you can see two of the best—Stanhope Forbes's *The Health of the Bride,* and Frank Bramley's *A Hopeless*

Dawn. These paintings are an inspiration to all students interested in realism. The fine draftsmanship and the masterful handling of tonal values are something to see. I have taken two of my Painting Holidays groups to the Tate to show them these paintings and tell them something of Newlyn and the painters who worked there long ago. During the heyday of the Newlyn School a street running uphill from the harbor was facetiously named the Rue des Beaux Arts—and not without reason: the cottages along that street contained some very notable paintings.

There's a touching story connected with the Forbes painting. The artist died in 1947 in his ninetieth year. Soon after, a memorial exhibition was held at the Newlyn Gallery. *The Health of the Bride* was borrowed from the Tate. Its subject is a wedding luncheon in the village hotel. The relatives and guests of the bride and groom are seated around a long table upon which we see the remnants of the meal—the crumbled bread, empty glasses, and a partly cut wedding cake. At the head of the table the best man stands with glass raised to propose the health of the bride, a pretty young thing, looking properly demure beside her robust husband. She is gazing with downcast eyes at the bouquet she holds in her hands.

Sir Alfred Munnings, who had been a student of Stanhope Forbes's and was then president of the Royal Academy, came to Newlyn to open the exhibition. In his opening address he had nice things to say about the Forbes paintings and not so nice things to say about museum directors who confine the Edwardian paintings in their collections to the cellars. At the close of his talk, a very old lady was brought to him. She smiled and said, "I thought you would like to know, Sir Alfred, I posed for the bride." I hope the great man kissed the little lady. I'm sure he must have.

I believe Forbes was the first real live artist I ever saw. I was about seven or eight at the time and was with my mother on the road between Newlyn and Penzance when a gentleman wearing a tweed knickerbocker suit rode by on a bicycle. I can still hear Mama say, "That was Stanhope Forbes, the famous artist." He was indeed a famous man in England then. With the coming of Modernism, he was forgotten except by a few diehards like myself. If mentioned at all, it was with cynicism. I'm happy to report the better painters of that school, of which he was one, are attracting attention again. Well, why not, didn't Jan Steen, the great Dutch old master, paint similar subjects?

Our current crop of critics, those purveyors of artistic double-talk, detest the type of painting I speak of. However, that doesn't surprise me considering much of the writing that passes nowadays as art criticism. I sometimes think the critics hate anything normal. They are coming around, though. Recently they have forced themselves to admire Winslow Homer's early paintings of pretty girls—those charming, crinolined damsels playing croquet on the lawn or

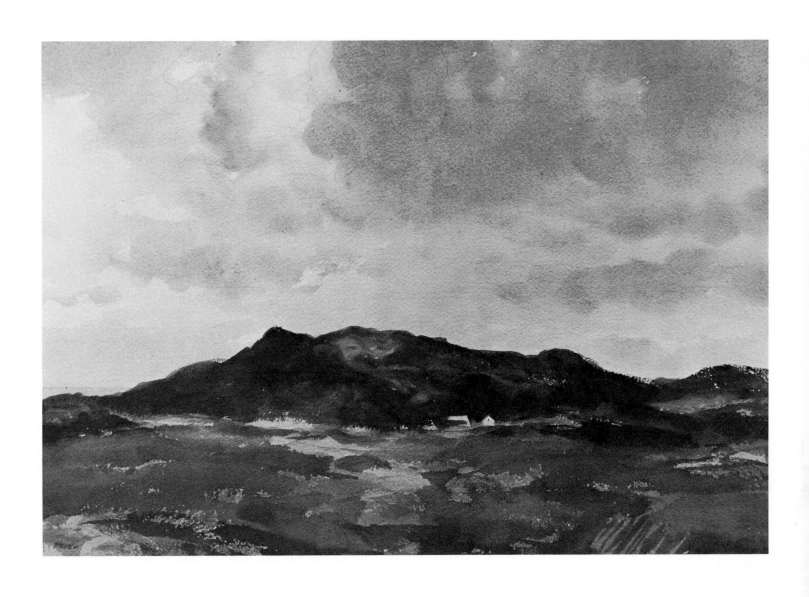

POLDARK COUNTRY
Watercolor on paper,
16 x 24 in. (40.64 x 60.96 cm)

This is a painting of the old tin mining area near the village of Zennor in Cornwall. D.H. Lawrence lived here during the first world war. He induced Katherine Mansfield to come down from London, hoping she would settle nearby. She didn't care for it. She said there were too many great rocks.

I guess this could be called traditional English watercolor. It is built up with transparent washes of grayed color and was painted from a small oil sketch made on the spot. The paper used was Arches 140 lb. cold pressed stretched on a board.

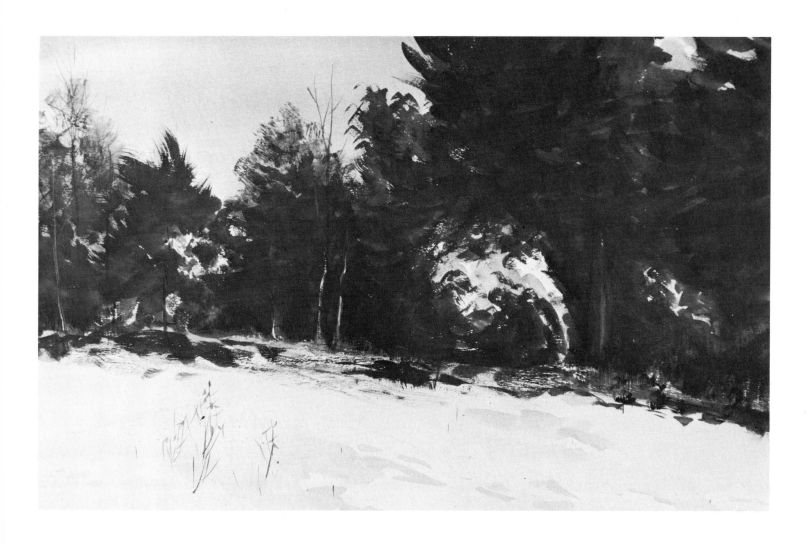

WESTPORT WINTER
Watercolor on illustration board,
15 x 22 in. (38.1 x 55.9 cm)

This is one of the many paintings I've made of the fields and woods in West-
port's Nature Center. It's just a short walk from home and I've painted there in
all seasons of the year. This one wasn't painted on the spot, however. It was
done in the studio from a pencil sketch made on a clear day. My painting *Fresh
Snow* a memory painting of this same area is reproduced in color on page 101.

The large patch of snow clinging to the pine intrigued me. In the early morn-
ing there would have been a lot more snow on the branches. As the sun climbs,
the snow falls. I would place this about eleven A.M.

sporting at the seaside. The critics feel safe with Homer. He is now an established American old master.

But to get back to Cornwall . . .

During the First World War I attended drawing classes at the Penzance School of Art where I worked in charcoal from casts and in pen and ink from the usual art school still life subjects—bottles, books, and other objects. Why pen and ink, I don't know. It seems strange to me now. I was thought too young to work in the life class, which I didn't think fair at all.

My first outdoor landscapes were pencil sketches of the coast and moorland around Penzance—these were done after the war when it was again permissible to sketch on the coast. On Saturdays I would ride my bike out of town to some favorite place in the country, like the quaint old village of Zennor, or even to Land's End or St. Ives. It was in Zennor where I made my very first on-location sketch. I hid behind a rock to do it . . . didn't care for onlookers in those days.

St. Ives, Cornwall's other art colony, is ten miles from my home. Some well-known painters have worked there. In 1895 Whistler was there with Sickert; Anders Zorn, the Scandinavian artist, had a studio there; and the American artist Frederick Waugh painted his first marines in St. Ives.

My parents and I left Cornwall for America when I was sixteen. We lived in Bridgeport, Connecticut, where I soon found a job as an apprentice with the Bridgeport Sign Company. It was something to do with paints and brushes, and that was good enough for me. The sign painters had an amateur art club which met one night a week to paint still life and copy color reproductions. It was there that I met a man who proved to be the first important influence in my life as an artist: Philip N. Yates, a wood-carver and painter from Philadelphia. He was in Bridgeport to do some artwork for the old Locomobile Company. He joined our art club, and we became close friends. On weekends we painted together along the Connecticut shore and in the country. Having grown up in Wilmington, Delaware, Yates had wonderful stories to tell of the Howard Pyle school and the men who had worked with that great teacher. Such names as Maxfield Parrish and N. C. Wyeth greatly impressed and inspired the green kid from Cornwall.

When Yates left Bridgeport to work in New York City, he suggested I follow him there and attend art classes. Soon after I arrived in the city, Yates introduced me to Robert Robinson, another Wilmington artist who had come to New York to study with Robert Henri. Robinson was holding life classes in his studio on Fifteenth Street. I found a job doing lettering for a one-man art service on Astor Place and joined the class in the evenings. Getting the tuition together on time each month wasn't easy. My salary at the art service was fifteen dollars a week, my room rent five. I don't recall that I worried much. Going a bit hungry now and then was a small price

to pay for leading the life of an art student in the big city. How romantic—or so I thought. On Sundays I would walk from Fifteenth Street to the Metropolitan Museum at Eighty-second Street and Fifth Avenue—quite a walk, but I could seldom afford the bus fare.

It was at the Metropolitan that I first saw the old masters. I stood in awe before the majestic Rembrandts. But I was also impressed by lesser men. Bastien-Lepage was one. His *Vision of St. Joan* has been a favorite of mine from the first time I saw it. I remembered that the painter had influenced the old Newlyn artist Stanhope Forbes. Perhaps that's why I was attracted. I never fail to see Lepage's masterpiece when I visit the Met. I can disregard the story it tells and just enjoy it as a marvelous painting of a Normandy garden which contains the best broadly painted plants and weeds I have ever seen—a great *plein-air* accomplishment. We should always bow our heads to Rembrandt, but never close our eyes and minds to the work of others just because they are out of fashion at a particular moment.

In two years I was on the move again. My friend Yates had returned to Philadelphia where he opened a frame carving shop. I worked for him and enjoyed learning the craft. I also had an opportunity to meet and talk with the artists who were his customers.

Edward Redfield was one of my heroes. He was the snow painter of the period. What impressed me was the fact that he painted his winter scenes outdoors and "all at one go," as he expressed it. This encouraged me to spend weekends painting snow pictures along the Schuylkill River and in Wissahickon Park. At that time I also met Antonio Martino, who was about my age. He, too, was painting snow scenes with a Redfield influence. Martino later became famous for his street scenes of the Philadelphia suburb of Manayunk, where Yates's frame shop was located.

We made trips to Chadds Ford to visit the studio of N. C. Wyeth. I was in awe of that great man but had some nice talks with him. I learned a lot about painting in the two years I spent in Philadelphia. The painters of Bucks County whom I met through Yates belonged to the group that has since become known as the American Impressionists.

It had been seven years since I left Cornwall, and as I had saved five hundred dollars, I decided to go back for a vacation and paint— where else, but Newlyn, of course. It was June 1927 and I was thrilled with the idea of painting in the village where, as a child, I had seen artists at work. It was at this time that I rented the old Langley studio overlooking the harbor. I had planned on taking a lot of work back to America, but something happened that I hadn't counted on—I fell in love with a pretty, vivacious brunette called Elsie. We were not exactly strangers, having known each other as children in Penzance. So, for the first and only time in my life, painting took second place. We had a great time. The studio was a wonderful place to give parties, and there were long hikes into the

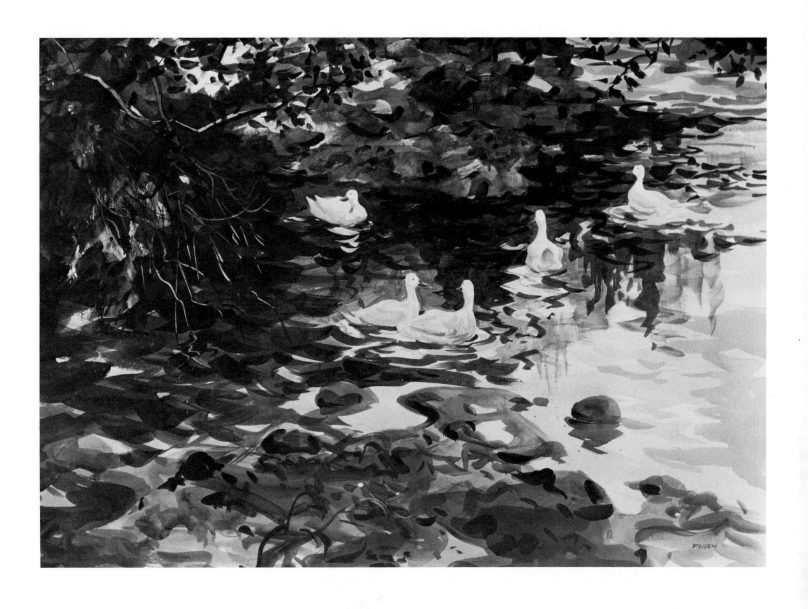

DUCKS IN STONYBROOK

Watercolor on illustration board,
22 x 30 in. (55.9 x 76.20 cm)

This was painted from an oil sketch done on location. Stonybrook winds
through Westport's Nature Center close to where I live and eventually flows
into Long Island Sound. Someone with property bordering the stream intro-
duced some pet ducks into it. They were so attractive I had to paint them. A 17"
x 20" Masonite panel and oil paint were used. The result wasn't bad, but didn't
express the fluid quality of the scene. It was too dark and heavy.

This studio watercolor from the outdoor oil sketch was painted rapidly one
morning, and was fun to do. Except for their shadowed parts the ducks are pure
white paper. I painted the background around them.

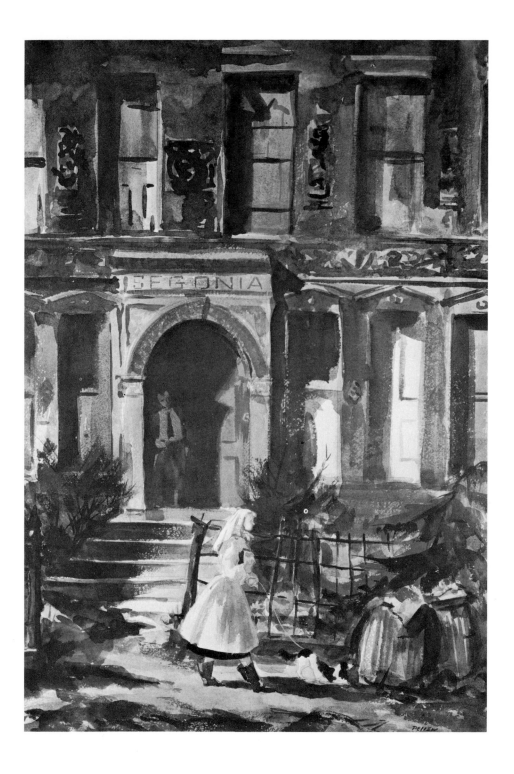

SEGONIA
Watercolor on paper,
22 x 30 in. (55.9 x 76.20 cm)

This is an old watercolor painted about thirty years ago, done in a part of Long Island City long since demolished. Knowing that this old section was doomed I made several paintings of its more picturesque parts. This must have been an imposing building in its day. I like to picture the owner proudly instructing the builder to place the name Segonia over the door. Was it the name of his hometown or maybe his wife's name, I wonder?

The first award I ever won in a major exhibition was given to this painting. At the 1949 American Watercolor Society Exhibition it received Second Honorable Mention. It was a thrill, and I was very proud.

country and along the coast to Mousehole, Lamorna, and other romantic places. We became engaged. I then returned to New York while Elsie waited out the quota before she could join me.

Back in New York I went to work for Street and Smith, publishers of pulp magazines, where I did lettering and dry-brush illustrations. I continued my weekend outdoor painting and attended evening sketch classes at the Art Students League. Elsie came in 1929 and we were married at The Little Church Around The Corner on October 5. I had found an apartment in Astoria, on the Long Island side of the East River just at Hell Gate. It was here, while painting along the river one morning, that the next great event of my life as an artist took place. A distinguished-looking lady stopped to watch and talk. She told me she had some paintings I might be interested in seeing. She lived in an old Dutch Colonial house a short distance away. I had often admired her home which was surrounded by beautiful gardens and an orchard—now, sad to say, long gone to make way for an ugly apartment complex.

What happened next was like a dream. I called at her house and saw the pictures. Some were hanging, others stacked against the walls. The masters of the nineteenth-century French school were brought out. The Impressionists and Post Impressionists were all there, as were some Surrealists, among them Dali.

The lady was Mrs. Cornelius J. Sullivan, one of the founders of New York's Museum of Modern Art. The paintings I saw that day now form an important part of that Museum's collection. Mrs. Sullivan came to our apartment, saw my work, and decided I should start exhibiting. She sent me to Marshall Landgren who had an exhibition space on the balcony of the new School for Social Research on Twelfth Street. It was exciting to see my paintings displayed for the first time in public where strangers actually stopped to study them.

Landgren made an appointment for me to see Miss Emily Francis. Once again a fascinating woman entered my life and gave me professional standing with the museums, collectors, and critics. This strong-minded, distinguished-looking lady had a gallery on Fifty-fourth Street called Contemporary Arts, where the work of newcomers was shown. She specialized in first one-man shows. It was not exactly the way to make a profit. Miss Francis was an idealist who lived in the back room of the gallery, dining often on rice and beans in order to keep her artists in the public eye. This great lady did more for the young men and women then struggling to obtain recognition than any dealer in New York City before or since.

I had my first one-man show at Contemporary Arts in February, 1934. Some of the other painters associated with the gallery at that time were Jon Corbino, Earl Kirkham, Milton Avery, Louis Bosa, Elliot Orr, and Joseph Stella. It was then I started submitting my works to the big annual exhibitions, with acceptances and rejec-

tions running about fifty-fifty. I wasn't complaining. I was accepted by the juries of the National Academy, Art Institute of Chicago, Pennsylvania Academy, Carnegie International, Corcoran Biennial, American Watercolor Society, and others.

In 1938 the Metropolitan bought my painting *Freight* from the Pennsylvania Academy exhibition of that year. I had painted it from the roof of our apartment in Astoria. It shows a freight train on the long approach to Hell Gate Bridge. The picture was hung on the right side of an arch; a Burchfield hung on the left side. Elsie and I went to the Met and took a photograph of it. I'm sure glad that photograph was taken because about a year and a half later someone in the front office must have given orders to remove the painting to the cellars. I don't think it has been hung since. Such are the highs and lows of an artist's life.

I was with Contemporary Arts for several years. I had three one-man shows there and took part in a number of group exhibitions. Monday night was open house. The painters, their wives, and friends would gather for shoptalk, coffee, and cookies; and there was the hospitable Miss Francis in her purple velvet gown that lasted longer than some of her artists.

Some interesting people came to openings at Contemporary Arts. I met George Gershwin there and Salvador Dali—also Thomas Craven, the author of *Men of Art,* a really great book. All the time that I was exhibiting around the country, winning some awards, and participating actively in Contemporary Arts, I was still working for a living five days a week. By now I was with *Collier's* Magazine as an associate art director. I held that position until the magazine went out of business in 1957.

Saturdays and Sundays were devoted to painting. Now there was also a daughter in our four-room apartment in Astoria. On the only two days Dad had to paint, the poor kid had to get out of her room so that he could use it as a studio. I have never painted at night. When the weather permitted, I worked outdoors. It has only been in recent years that I have had what might be called a studio. It isn't much, just a small shack on the edge of the woods behind the house. But the windows look out on what is my real studio—the great outdoors. All I have learned about landscape painting has been learned face to face with nature. The only thing I learned in the short time I spent in classes was how to draw.

The apartment life in Astoria lasted twenty-seven years, years in which Elsie saw to it that I had the room and peace in which to paint if I wanted to work indoors. For that, I shall be ever thankful.

In 1957 we moved to Connecticut. *Collier's* had folded, and Albert Dorne, one of the many famous illustrators with whom I had worked on the magazine, asked me to come to Westport. He was president of the Famous Artists School in that lovely New England town on the Saugatuck River. I came, liked what I saw, joined the faculty, and taught four days a week for fifteen years.

Getting out of New York City to live in our own home, on our own land, with our own trees, was like going to heaven. Of course, when we were city dwellers we did have vacations—some in the New Hampshire mountains and some on the Maine coast, where I met and painted again with my old friend Philip Yates. However, to be actually living in the country was thrilling. I still watch with loving interest the changing seasons in the woods behind the house. I've painted them over and over. I can now paint every day. It has taken a long time to reach that goal, but I don't regret any of the past. It was interesting and often exciting. Now and then, as a change from landscape, I do a figure or family portrait. Commissioned portraits are not for me. I have never had the desire to enter that field.

In 1965 I started doing workshops for Painting Holidays. Three or four of these each year since has given me the opportunity to teach and paint in many parts of the United States, Mexico, and Europe—even Cornwall where it was a joy to show participants the scenes of my childhood. Through the workshops Elsie and I have made a host of great friends. It's been a wonderful life.

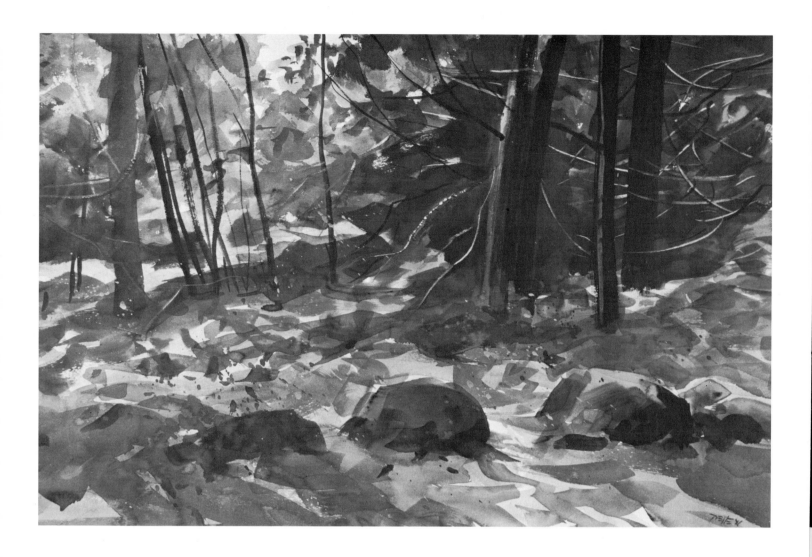

THE SUNLIT WOOD
Watercolor on illustration board,
15 x 22 in. (38.1 x 55.9 cm)
Collection Mr. & Mrs. Einer Setterling.

This is a forty-five minute demonstration sketch painted for my outdoor class at the Silvermine Guild. In doing it I tried to show how bold, untroubled washes put down with a large brush will result in a better watercolor than one niggled at and worked over with a small brush. The morning this was painted my class was filmed for TV. The ABC crew with Anna Bond were filming around Silvermine for a "Connecticut Weekend" bit and included us. All my students watched the six o'clock news that evening.

INTERVIEW WITH JOHN PELLEW

I have been asked a series of questions by the editors of Watson-Guptill about such things as my studio setup, my working methods, the materials I prefer to work with, and my techniques. I have also been asked questions that are similar to ones asked me by students over the years. I hope my answers will help you to understand better how I work and why I paint.

Are watercolors your favorite medium?
Why do you like them so much?

This is the question that gets asked at every demonstration and every workshop. The answer is I don't have a favorite medium. I am an artist and I'm certainly not going to miss a lot of the joy of being one by specializing. I love watercolor. Surely this book proves that. I also get a thrill pushing rich, juicy oil paint around with knife and brush. Many great watercolor painters also painted in oils. How about Turner, Homer, and Sargent? What started this specialist thing? I think it came about when the first watercolor societies were formed in England. In the Royal Academy exhibitions watercolors had been slighted and badly hung. Even our National Academy insists on a separate class for watercolorists. I think that's dumb. An artist is an artist or painter, and I don't care if he mixes his paints with water, oil, or maple syrup, it's the result that counts. No, I couldn't possibly have a favorite medium.

Do you ever work with opaque watercolors?

No, I don't use opaque watercolors. For an opaque technique I prefer acrylic or oils. True, in some of my watercolors there may be some opaque passages due to a mixture that contains more paint than water. This can happen when working on location where it's necessary to put down the tonal values as rapidly as possible. The sun doesn't stand still; there's no time to build up tones with superimposed transparent washes.

You also work in acrylics. Do you use acrylics
as a watercolor medium? Why?

I guess I am what is called an intuitive painter. For instance, when I start out for a morning's painting from nature, if I have acrylics

with me, that's what I'm going to paint with. However, I don't know until I start if the final result is going to be opaque or in a transparent watercolor technique. After a few preliminary washes to establish the composition, I may decide it's a fair start for watercolor treatment and do the picture from start to finish in that manner. Then, again, I could get halfway through when some fantastic sunlight and shadow effect occur that could be captured more rapidly with opaques. Then I might sacrifice the watercolor and change over to opaques immediately. I can't tell you why. Intuition, I guess.

How would you compare acrylics with watercolor? Do you reserve each medium for painting specific kinds of subjects?

How can you compare them? They are different mediums even though both can be thinned with water. However, one advantage of acrylic over watercolor is that acrylic can be used in both opaque and transparent techniques. I can't conceive of a reason for reserving a medium for a specific subject. You can make a good or bad painting of anything with either medium.

Do you ever paint a subject in one medium and then decide to repaint it in another? Why might you do this?

I have done this occasionally. When looking over some old paintings, for instance, I might decide that a two-year-old oil sketch has the makings of a good watercolor, especially if I make some changes in the composition—changes that wouldn't have been necessary if I had been on the ball originally. This is something to do on a rainy day. I haven't done it often.

STUDIO, MATERIALS, AND EQUIPMENT

Can you briefly describe your studio?

I hesitate to call the place in which I do my indoor painting a studio. I recall that John Constable in his letters referred to his place as "my painting room," and that's how I think of mine. It's not perfect; but, as most of my painting is done on location, it serves me well. It stands at the edge of the woods beside a white birch. The wooden building is stained New England red, a fair-sized window faces north and a smaller one with white shutters faces east. There's a white Dutch door with a hex sign painted by my daughter Elma on its upper half. The inside measures twelve by twelve feet. A studio easel stands in the center of the floor with a table beside it. There's an enameled tray on the table used as a palette for all three mediums when I work here. Against the back wall is a gas stove fed by two tanks on the outside. On the wall above the stove there's a shelf on which sit bottles, cans, and jars containing painting mediums and dry powdered colors. On the window ledge there's also a

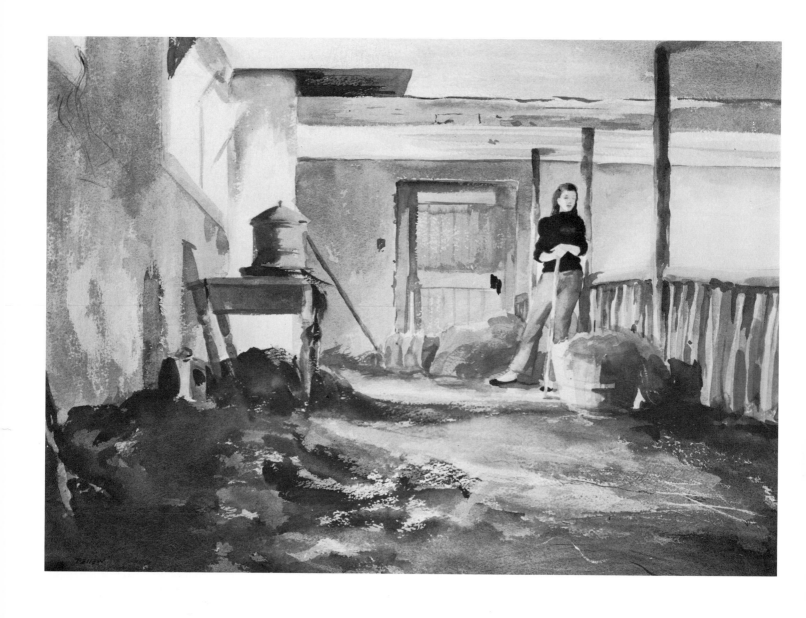

BARN INTERIOR
Watercolor on paper,
22 x 28 in. (55.9 x 71.12 cm)

I was lucky enough to see this barn before its new owners cleaned it up. I saw it later and no doubt it was fine from a farmer's point of view, all neat and tidy, but as a painting subject it was the pits.

My model complained of the smell from what can be seen in the left foreground. Actually I found the color so beautiful and the shape so interesting I wasn't aware of any odor. The creamy white walls and ceiling were complemented by the warm color of the floor and the whatsit in the corner. The only cool color is the phthalo blue sweater worn by the model.

long row of powdered colors in small jars. Canvases and frames stand against the right-hand wall. On the opposite side there's a small chest of drawers containing paints, brushes, and other tools of the trade. There is also a chair in front of the easel, and that's it. Of course, a big studio to rattle around in is a nice thing to have, but not really necessary. That famous American, Albert Pinkham Ryder, ate, slept, and painted in a cluttered room in an old brownstone house in Greenwich Village, New York City.

What watercolor brushes do you use?
What do you use each one for?

I use both round and flat sables. The flats are one and three inches wide. The three-incher now commands such a high price in the stores I'm scared to use it. Instead, I use some flat, long-haired house painter's brushes that I find work just as well for me. I use them on paintings that are full sheet or larger. On half and quarter sheets I use the round sables—number 5, 8, and 12—along with the one-inch flat and a rigger for fine lines. A question that pops up at most demonstrations is: what size brush are you using now? This always bugs me because I could probably do whatever I was doing at the time with another brush, smaller or larger. Some people think there's a formula for doing everything.

What are your favorite watercolor papers?
Why do you like them so much?

I have used Arches, RWS, and Capri. I prefer the cold-pressed surface in each. I find the rough papers are too rough for small watercolors. For the past three years I have used a lot of Strathmore illustration board. It has a fairly smooth surface that I find pleasing to work on and it doesn't buckle. The watercolor papers I use are 140 lb. weight.

What are the colors on your palette?
What do you like about each of these colors?
And what do you use each one for?

The colors on my palette are cadmium yellow light, yellow ochre, raw sienna, cadmium orange, cadmium red light, burnt sienna, cerulean blue, phthalo blue, and burnt umber. Greens I mix using combinations of the yellows and blues. Beautiful rich greens can be obtained with raw sienna and phthalo blue. I keep in mind always that a little phthalo goes a long way. It's remarkable what a great variety of greens I can get with my two blues and three yellows. Sometimes, to warm or give richness to a green mixture, I will add some burnt sienna or cadmium orange. A nice olive kind of green can be mixed with just burnt sienna and phthalo blue.

For gray tones my usual mixture is phthalo blue with a little cadmium red light. I like to use cerulean blue pure for distant headlands at the shore or those faraway hills in the country. I don't use

black in landscape but get deep darks with phthalo blue and burnt umber.

What kind of watercolor palette do you use? Why?

In the studio I use a large enameled tray. On location I use a heavy metal folding palette with indentations on its outer edges for paints and three saucerlike depressions in each half for mixing washes. It is called the Millard Sheets' palette. I've had mine twenty-five years. I don't think it's on the market today.

How do you lay your colors out on the palette?
Do you ever vary the sequence?

My colors are always in the same place on the palette. I never vary. I don't want to have to search around for them. Here is the layout from right to left: cadmium yellow light, yellow orchre, raw sienna, cadmium orange, cadmium red light, burnt sienna, cerulean blue, phthalo blue, and burnt umber. I always carry alizarin crimson but only put it out for special things like flowers or autumn foliage. I have two prepared greens.

What other tools do you paint with?
Razors, sponges, whisk brooms, cardboard?
What do you use each of these tools for?

I use only oddball tools when painting my studio improvisations. I use razors for lifting out when I need to lift a wider area than my fingernail can, and cardboard for scraping one wet color into another. I have even used an old, worn whisk broom to suggest weeds and beach grass against the sky, as in the painting *Island Winter*.

What, if anything, do you use to speed
the drying process?

When working in the studio, I use a hair dryer. Working outdoors, I use the sun if there is any. You can't plug into a tree or a sand dune.

What natural light do you have in your studio?
What artificial light do you have?
Which do you prefer? Why is that?

The studio has two windows, one facing north and the other east. As I never paint at night, there's no artificial light. Landscape painting is a daytime occupation; night work is for commercial artists who have to meet deadlines.

TECHNIQUE

Do you tack your watercolor paper down, stretch it,
tape it, or glue it before painting?

In recent years almost all my watercolors have been painted on illustration board. Because of its thickness, there's no need to stretch

it. I simply fasten it to my board with four strips of masking tape across the corners. If there's a slight warp when it's taken from the board, I carry it over to the house and slip it under a rug. Next morning it's quite flat. People laugh when I tell them this. I don't know why, it seems sensible enough to me.

Do you work flat, on a diagonal, or vertically?

I paint watercolors with the paper in an upright position outdoors and in the studio. The only time I don't do this is when I paint my studio improvisations. Some of these need a wetter technique than usual so I put my board on a slightly tilted drawing table, which I forgot to say is also part of my studio furnishings.

What size paper do you like to work on? Full-size? Half-sheet? Double-elephant? When do you use each kind?

When demonstrating for a class outdoors, I use half-sheet papers which are small enough to finish in a reasonable length of time. They are also large enough for the students to see what I'm doing. I never paint full sheets on location. One should not spend more than an hour on a watercolor outdoors. My half-sheet demonstrations are mostly done in forty-five minutes. Painting full sheets in the field is indulging in an ego trip, in my opinion. My large thirty-by-forty-inch papers are done in the studio, and then not often. I'm not really fond of very large watercolors. They came about because they had to compete on the walls of the annual exhibitions. Remember the old saw: "If you can't make 'em good make them big." Working for myself on location, I paint quarter and even eighth sheets.

Do you sponge the paper down or prepare it in any other way before painting?

Outdoors I work directly on the dry paper. In the studio, when improvising on illustration board, I first wet the paper with clean water. This is to slow down the drying. Outdoors I want the drying to be as fast as possible.

When do you use drybrush technique?

Drybrush is used to suggest textures or to create some variety in the brushwork. I don't plan to use it ahead of time. I don't tell myself I will paint a picture using drybrush in certain parts. I don't work that way. Watercolor for me is a bravura medium and the drybrush parts of a picture just happen spontaneously. If I were to analyze the reason for doing each thing as I worked, all the fun would go out of doing it and the all-important personal style would never evolve.

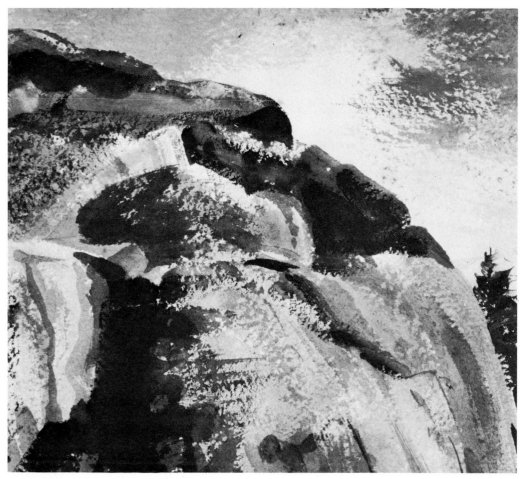

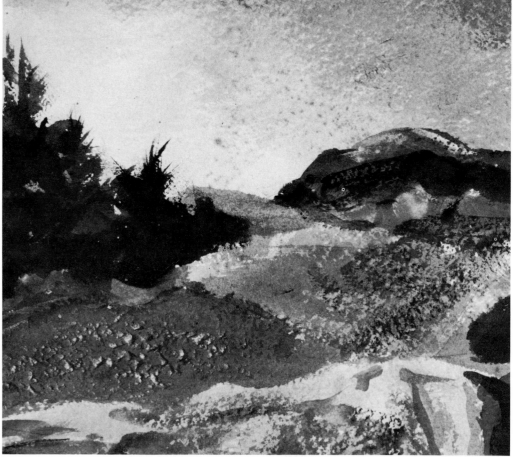

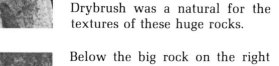
Drybrush was a natural for the textures of these huge rocks.

Below the big rock on the right there is an area of dark drybrush that was painted with a one-inch flat brush dragged rapidly over the dry surface of the rough paper. On the left below the dark trees there are some lights suggesting small rocks or pebbles against a gray tone. These were lifted out of the wet paper with the point of a razor blade.

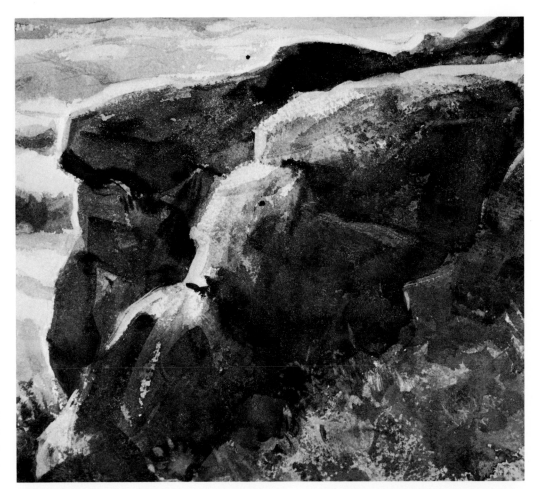

These rocks have been given great solidity by the use of a strong top light with some drybrush. In the right foreground more drybrush was used for the grass and weeds.

These rocks were kept simple and the weeds between them were done by scraping wet paint with a fingernail.

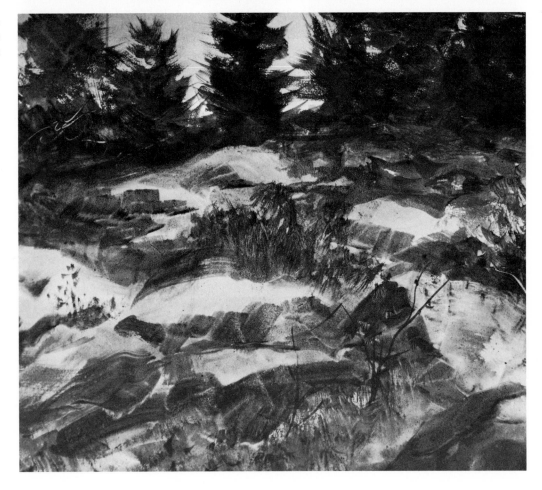

**Do you prefer to mix colors on the palette
or on the paper? Why?**

I paint two kinds of watercolors—my landscapes painted from nature and my studio improvisations. For the first I mix color and tonal values on the palette; for the second I often allow colors to mix on the paper. In my outdoor landscape work I am more concerned with obtaining the correct tonal value than with exactly matching the colors of nature. Suppose Turner, Winslow Homer, and Renior were each painting the same scene at the same time. Each picture would have a different color scheme. Color is a very personal thing; values are constant.

**Do you have any colors or color schemes
you like? Why?**

I don't impose a color scheme on nature. Nature dictates the color scheme of my painting. There may be, in fact, there usually is, a dominant color to any landscape. For instance, in the fall the dominating color may be a golden yellow or, depending on the kind of country, it might be a red orange. The painting would then have one or the other as its dominating color. Likewise, in the spring it might be a pale yellow green. But I don't invent color schemes—they are there before me in nature. If I'm painting the autumn fields and woods, I know before I start that my picture will be warm in color. If I'm doing the ocean under a blue sky, it's going to be mostly cool in color. That's as much thought as I give it. I told you, I am an intuitive painter.

**Describe your actual procedure for painting
in watercolors. How do you begin? Do you sketch
on the paper first?**

When doing a teaching demonstration for students, I can proceed a step at a time with a "first-you-do-this-and-then-you-do-that" kind of approach. When working on my own on location, I have no predetermined procedure, or, if I have, I'm not aware of it. I'm too excited about getting that beautiful stuff down on paper before the light changes. I might start with the sky at the top and, working downward, finish at the bottom with the near foreground. Then, again, I may decide to lay in some big flat washes of local color to be developed later with superimposed color washes and maybe drybrush texture. The sky might even be the last thing painted. These decisions are all made on the spur of the moment while I am painting as fast as I know how. Call it intuition, call it experience, call it what you will. I just know I don't have to think ahead of time how I'm going to proceed. Some teachers think they can reduce everything to a formula, and their students' paintings reflect this restrictive type of training.

Yes, I first lightly sketch the main masses of the composition on the paper with an HB pencil—just the big shapes, no details.

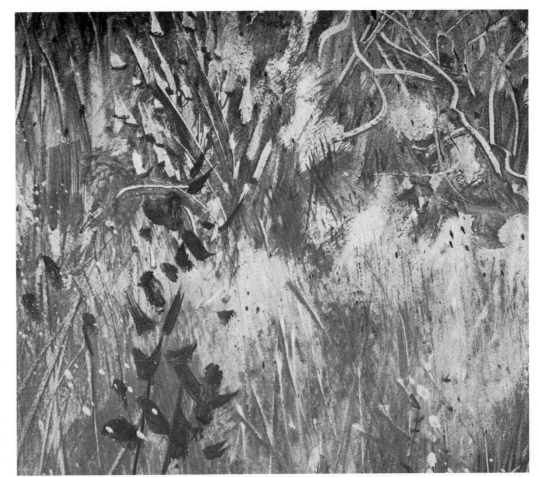

Two kinds of fingernail scratches were used to suggest tangled undergrowth, both done in wet paint. On the right are some thin wiggles done with a rapid downward stroke. To the left of these are some broader strokes also lifted with the fingernail. For this tricky bit I used four fingers held together, attacking the paper with short chopping strokes.

This is a great close-up of some broad fingernail work in wet paint. These light strokes were done with a stabbing downward movement of four fingers. The small round lights are opaque spatterwork.

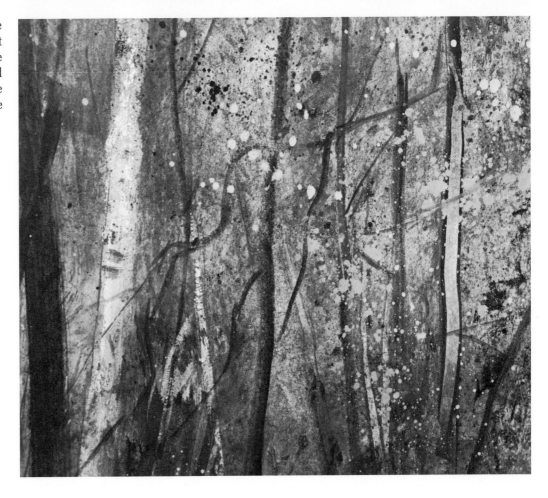

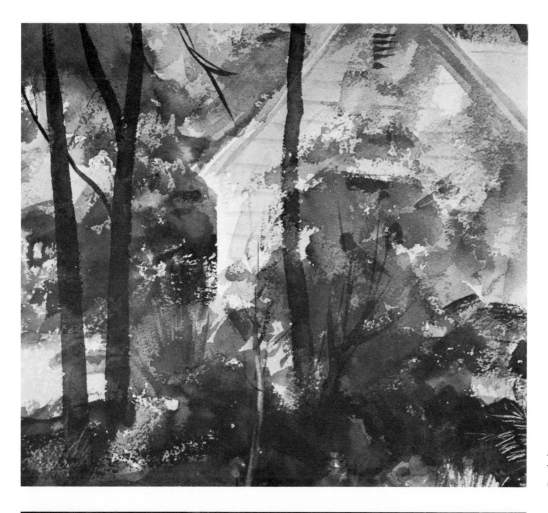

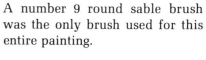

A number 9 round sable brush was the only brush used for this entire painting.

The foliage and grasses were painted with a house painter's brush and round sables, numbers 8 and 10, were used for the figure. Strong top lights on the back, shoulders and top of the girl's head add to the illusion of solidity. The light strokes in the grasses were fingernail scratches in damp paint.

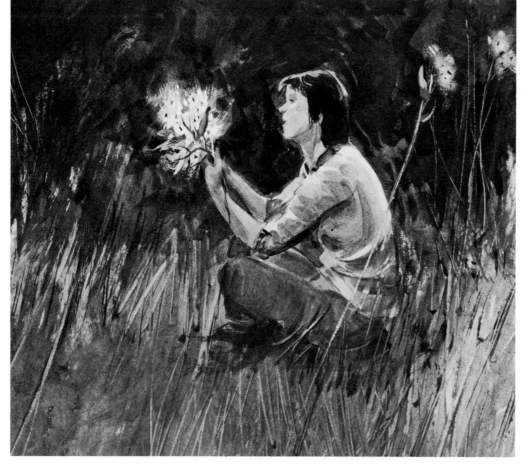

Do you generally work from light to dark? Why?

Most, not all, watercolorists work from light to dark, with the darkest darks going in last. I use this procedure more than any other, although I experiment with other procedures now and then. The reason for working from light to dark is that in watercolor a dark can always go over light, but you can't paint a light over a dark without using opaques. The darkest values go down last.

**Do you tend to start out with big brushes, then
gradually work toward smaller brushes?**

I generally start with a one-inch flat sable, then move to a number 10 or 8, and perhaps finish with a number 2 or a rigger if fine lines are needed.

**How do you decide what exactly to paint?
Are there any special qualities you look for
when you select a subject to paint?**

Nature is *full* of special qualities—you don't have to look for them. I have no patience with the person who goes to the country or the shore and then spends half the morning wandering around looking for something to paint. These poor people are not happy with straight landscape—they must have *a subject,* something added to the landscape. It could be an old wagon, a beached boat, a broken rocking chair in the grass, or, best of all, a weathered barn. These folk have the instincts of the illustrator, not of the painter. A stretch of country bathed in light and atmosphere is enough for me. Sometimes it's the sky that sets me going, or it could be the flickering lights and shadows in a pine woods, trees reflected in a pond. I don't have to select a subject—I just go outdoors and there it is.

**Do you ever use a viewfinder or some other
device to help you select a subject?**

No, I simply make a frame with my fingers and thumbs. It serves the same purpose and has the advantage of never getting lost.

**Are there any special kinds of compositions
you prefer? Why do you like them?**

There are only two kinds of compositions: good and bad. There are some simple kindergarten rules to be learned that are good to know—such as, don't divide the space through its center either horizontally or vertically. Others are: don't place a dominant point of interest in the exact center of the picture, and don't have two things of equal importance competing with one another in the painting. What it comes down to is the fact that composition is a matter of good taste. When working in flat country, I like to place the horizon well below the center of the picture space, making the cloud shapes an important part of the composition. I like landscape com-

positions that are made up of a few big shapes, a design based on a good abstract pattern. I think a feeling for design is born in some of us; it can be acquired by others through study.

Are there any special kinds of light that intrigue you more than others? Why is that?

Yes, there are. Early morning and late afternoon are both special. Unfortunately, it's impossible to get a painting class into the field before breakfast. The hours between six and nine are the best of all. The sun being lower, the shadows are longer, and this makes for a more interesting light-and-dark pattern than that which occurs at midday. This is also true of late afternoon; the shadows are long and the color rich, but the effects are fleeting and one has to work at top speed to capture anything worthwhile. I've been told that Sargent's watercolors were painted during the blaze of noon. That's because he lived the life of an English gentleman and wouldn't think of painting on location before breakfast or missing afternoon tea. So you can paint at noon—he did, and did very well indeed. However, I still prefer the special times I have mentioned. My noontime watercolors just don't have the deep tonal value contrasts I like to see in a painting.

Do you try out value arrangements, compositions, and color arrangements in sketches before you start painting?

I encourage beginners and students to do so, but don't myself. For me it takes up time that I feel could be better spent capturing an exciting or subtle lighting effect. As for composition, I know that a picture, before it is anything, is an arrangement of shapes on a flat surface. I rapidly sketch in my big shapes, ignoring the little ones, and go to work. If the painting doesn't go well, I turn the paper over and start again. I tell students that the best way to study and learn to see tonal values is to paint black-and-white studies from nature.

What kind of subjects do you like to paint? Why?

That's a difficult question to answer. My friend Tony van Hasselt once said, "Sit Jack down anywhere and he will paint a picture." I think a landscape painter has to be a nature lover. I find all landscape interesting. Some may think the woods are my favorite subject, but that's because it's outside my back door. When I lived in New York City, I painted street scenes. I like all kinds of subjects—landscape, especially landscape under dramatic or intriguing lighting, coastal scenes, desert, or country will always stir me into action. I have no desire to be a specialist in one subject.

Do you ever put a painting aside for a while to think about it, and then go back to paint it?

All my watercolors are finished at one go; so all my thinking, for better or worse, has been done. If it should happen that I am not too

This shows the staccato brush-work used to suggest the jumble of rock in the dry creek bed. Instead of drawing each rock I simply used a half-inch flat bristle brush quickly to put down a variety of strokes and to create an impression of the whole.

Notice the soft rendering of the tree mass and the swift brushwork of the reflections in water. The spontaneous brushstrokes create a feeling of movement in the water.

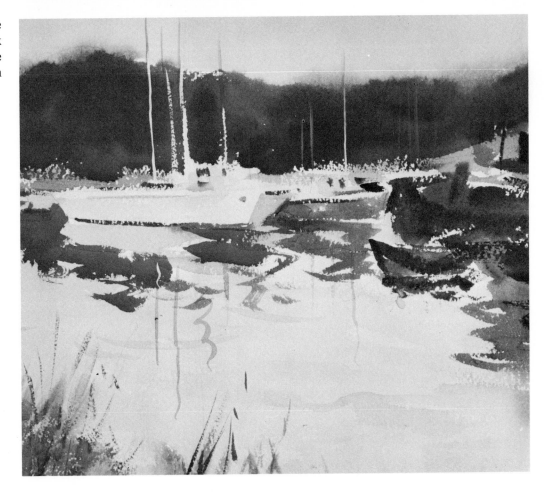

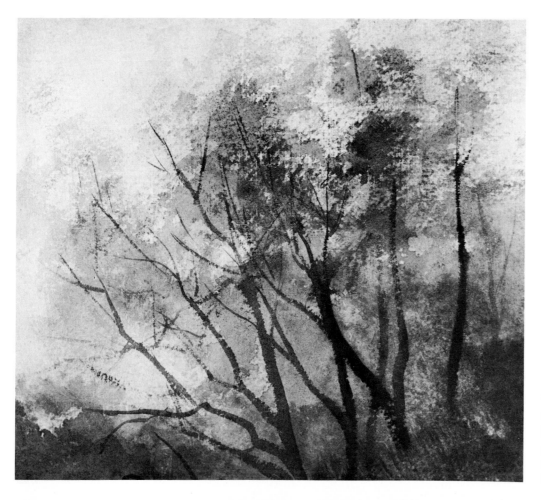

To suggest twig masses, I used a lot of drybrush. Because the paper had dried when this went in, the grain of the paper shows up well. I used a one-inch flat brush, both flat on the paper and on its side.

This clearly shows the granular drybrush textures that are most easily obtained on rough-surfaced papers. The loose drybrush edges, where the foliage meets the sky, create the illusion of sunlight shining through the foliage. This effect would be difficult to achieve on smooth paper.

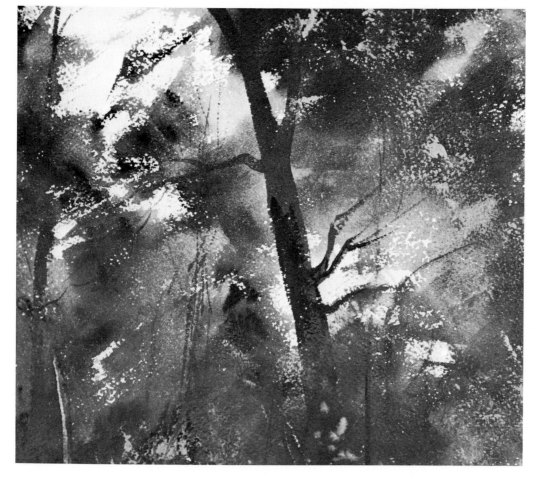

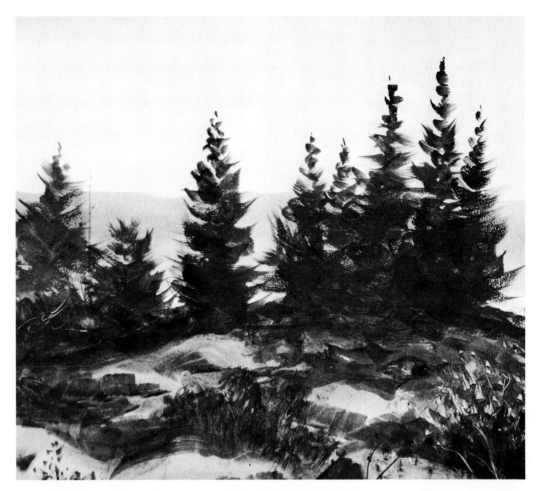

The kind of brushwork used for the pointed firs that are found on most of Maine's headlands are illustrated here. I used a half-inch, flat bristle oil brush and starting at the top of each tree—I went flip, flip, flip, with strokes to left and right, working my way downward.

The tree trunks against the sky in the group to left of center were done with a drybrush on smooth paper. The light branch coming in from the right side was a fingernail scratchout.

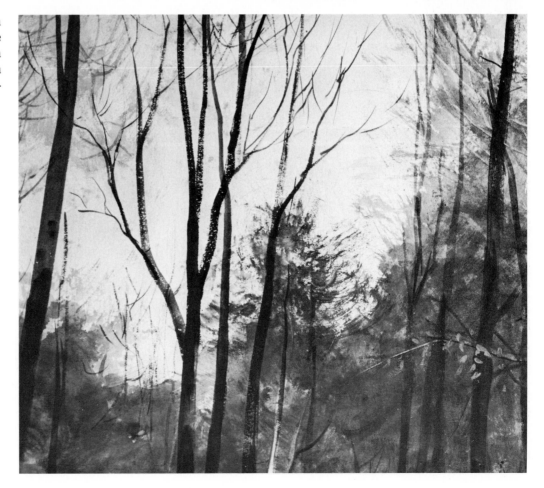

happy with a painting after having it around for a while, I might try doing it over or I could tear it up.

How do you know when a painting is finished?

Finish is a broad term. Finish for some artists would not be finish for others. As I think watercolor should be used to make an understatement, my painting is finished when I feel that more work would only destroy the charm of the understatement. When applied to watercolor painting, no truer words were ever said than, "Quit while you're ahead."

What kind of framing and matting do you prefer for your paintings?

I don't like colored mats, nor do the hanging committees of the important exhibitions. I like my watercolors to have a white or off-white three- or four-inch mat. I don't like watercolors framed close up like oils. My frames are simple moldings, one or two inches wide. I dislike the nonglare glass, as do most professionals. It kills the feeling of a watercolor being a handmade thing, and makes it look like a reproduction.

When you run into trouble with a painting, do you try to save it? Do you scrub out passages and repaint them? Or do you just start all over again?

I don't often run into serious trouble while painting on location. That doesn't mean I don't ever bomb out—everyone does. If I'm halfway through an outdoor watercolor and decide it's on the way to being a stinker, I turn the paper over and start again. I've painted some of my best watercolors on the back of a bad start. I guess that's because all my inhibitions had been worked out on the first one. Studio painting is something else. There's more time. I'm not racing against that ever-moving sun. I sponge out, scrub out, and repaint if necessary. I even take the paper out onto the lawn and use the hose on it. This treatment leaves very subtle color tones on the paper, to be made use of in the repainting.

Do you ever stop to look at a painting in a mat while you're working? How does this help you?

Yes, I carry a mat with me on location. I lay it on the painting maybe twice during the working period. It tells me when to stop; it keeps me from overworking. More watercolors are ruined by overwork than anything else.

As a landscape and seascape painter, do you paint primarily on location?

Yes, most of my painting is done on location. My larger exhibition pictures are done in the studio. These may be only four or five a year, and they are sometimes painted from studies done in the

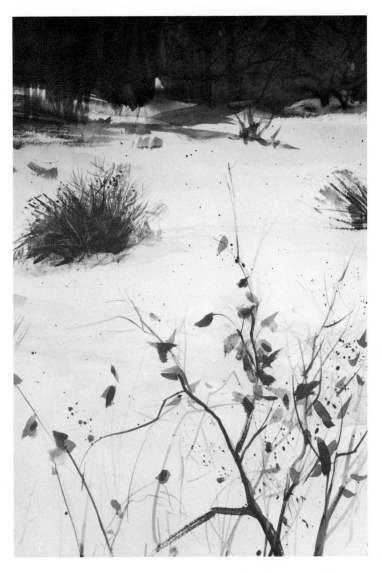

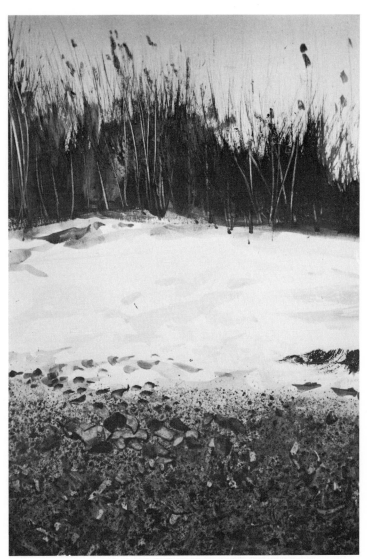

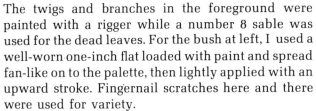

The twigs and branches in the foreground were painted with a rigger while a number 8 sable was used for the dead leaves. For the bush at left, I used a well-worn one-inch flat loaded with paint and spread fan-like on to the palette, then lightly applied with an upward stroke. Fingernail scratches here and there were used for variety.

I painted the thin weed stalks against the sky with an old whisk broom, rendering fifteen or twenty with a quick upward flip. The dark spatter that went over the undertone in the foreground was allowed to dry first. While the heavy spatter was still wet, some quick stabs with the fingernails, using four fingers together, brought out some lights suggesting the larger stones.

field, sometimes from memory. After years of going to nature, one builds up a strong visual memory. It is in memory work that an artist's personal style grows. This is where the painter's unique vision of nature happens. I believe it was Robert Henri who said, "The good thing about working from memory is that so much is forgotten." It is true that when face to face with nature, one is tempted to look long at unimportant details or to develop a part to the point where it becomes a separate project destroying the unity of the picture. A good picture has oneness. When painting from nature, one should not try to compete with nature. To quote Cézanne, "Painting from nature is not copying the object, it is realizing one's sensations."

If you use photographs, how do you use them?
Do you sketch from the photo and then paint,
or do you paint directly from the photo?

I sometimes make use of photographs, but as reference, to refresh my memory of the subject, not to copy. The finished painting often bears little resemblance to the photograph that acted only as a stirrer-upper of the memory. I have tried painting from projected color slides, which seems to be a favorite method with many artists and students. Unless photographic realism is what the painter thinks of as art, this method is dangerous. One gets trapped into following the color slide too closely, and, if the painter is a skillful technician, the end result is simply an enlargement of the photograph that was taken by a machine without either imagination or the capacity to think. These terms might also apply to that skillful technician. A better method is to make a black-and-white drawing from the photograph, then put it away and paint from the drawing. This avoids color copying. I find the film that gives me color prints, rather than transparencies, more useful when a photograph is needed to jog my memory. The camera can be a useful tool; but, like the cigarette package, when purchased by an artist, it should carry a warning label.

PHILOSOPHY

In your estimation, what criteria make
a painting successful—or not?

A good composition, interesting color, and the mood of a particular day and place established simply in a personal statement. In watercolor it should be an understatement where everything is not fully explained, leaving something for the viewer to work on. In my opinion, it should not compete with the camera. The interest should be in how it is painted, not what is painted. It should be a creative effort in which the handwriting of the artist plays an important part—in other words, a personal statement that doesn't ape the work of someone else.

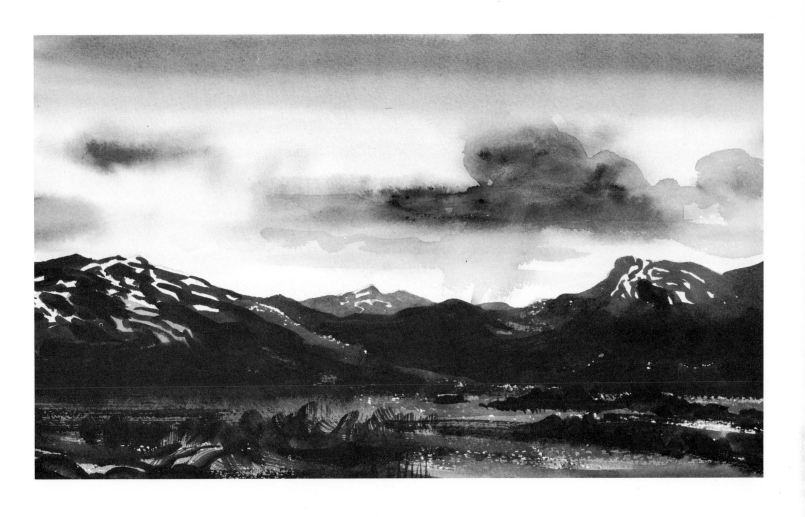

COLORADO EVENING
Black and white value sketch on paper,
6 x 10½ in. (15.24 x 26.7 cm)
This black and white value sketch was painted for a class to demonstrate two things: first, that it's possible to learn to observe tonal values better by working in one color; and secondly, to stress the importance of working from memory, as I was doing here, where only the important is retained and the unimportant forgotten.

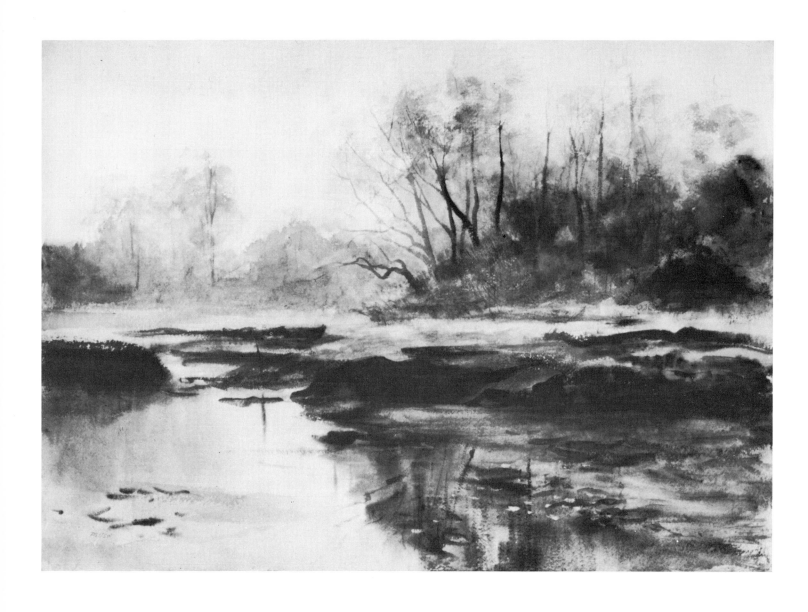

A GRAY DAY
Watercolor on cold-pressed paper,
22 x 30 in. (55.9 x 76.20 cm)
Wenzel-Woodford Collection.

Another of my favorite painting locations is this tidal inlet on the Connecticut shore. A stream comes down from the hills to meet the ocean and several miles of salt marshes are formed. This is a studio painting from a small oil sketch done at this location. I have often painted watercolors from oils and vice versa. This one was started wet into wet. I soaked the paper in the tub for roughly ten minutes. After blotting up the surplus water with a towel, I painted the gray sky tone from the top down to the grassy banks. Then I used the same tone for the water, leaving the flat area between the water and the trees as white paper. The gray of the distant trees was the next step; some of this gray also went into the water. A yellow ochre wash was then painted over the area that had been left white and, while it was still wet, some of the gray tree tone was pulled into it. Next came the high, dark bank supporting the trees and the dark middle tones of the water. After some time out for drying, the tree trunks and the water's darkest darks were put in. The light on the water was sponged out and the dry-brush suggesting twig masses put in. I used only three colors—yellow ochre, burnt umber, and phthalo blue. All grays are mixtures of the last two.

As a professional artist, what advice would you give beginning professionals?

I would advise the beginner not to think of art as a profession in which it is possible to make a lot of money. Some, a few, depending on their personality and ability, can make a living from sales—not a great living, but enough to allow them to live as artists. Others with as much or more talent, but lacking the promotional ability to open doors, must teach or earn money in other ways in order to live and go on painting. Some artists marry wealth, some inherit wealth; some of these are good painters, some bad. Money won't make you a good painter if you don't have what it takes to start with. My next piece of advice would be to read that great book, *The Art Spirit,* by Robert Henri. His words have been an inspiration to thousands of artists. I would also tell the beginner to study the masters and know what they did. Don't just study today's prize winners and ignore the past. Twenty-five years from now many of our contemporaries will have been forgotten. If you think I'm exaggerating, look up some old catalogues of our big annual exhibitions. The best advice of all is to paint, paint, paint. How well you will paint depends on how often you paint.

How did you decide to devote yourself to painting?

I sometimes think these things are decided for us. As far as I know, there was never an artist in my family. But, as a very small child in school, I loved to draw and color. The art lesson was always the important one for me. As soon as I was old enough, I borrowed books on art from the public library and I went wherever paintings could be seen. Growing up in Cornwall near two art colonies, I went to the local shops and galleries of St. Ives and Newlyn where paintings were always on view. From an early age, I wanted to paint pictures. One day, when I was about twelve years old, I saw the English naturalist painter Charles Simpson painting some gulls at low tide in St. Ives harbor. If ever I made the decision, it was made that day. I was thrilled.

Who are the artists you particularly admire? How have they influenced your own work?

I will first list the nineteenth-century British watercolorists whom I greatly admire and who have influenced me: J. M. W. Turner, Thomas Girtin, Richard Parkes Bonington, John Sell Cotman, Peter De Wint, Samuel Palmer, and Arthur Melville. I studied Bonington for the beauty of his street scenes; Cotman for the design of his big simple masses; De Wint for his lovely transparent washes; and Melville for his unusual compositions. I admired them all, but the last four influenced my own work. Of the Americans, I have studied the following with interest: Whistler, Winslow Homer, Maurice Prendergast, Charles Burchfield, Edward Hopper, and the

early Andrew Wyeth. Whistler had such exquisite taste, Homer such power. Prendergast was an original; Burchfield and Hopper were as American as apple pie; and the early Wyeths I admire for their spontaneity.

**You've been painting for forty-four years now.
That's a long time to do anything. How have you
sustained your interest in painting?**

That was never a problem. The interest was always there and I never had to work to sustain it. Even when I had a desk job in order to support the family, my last words when leaving on Friday afternoon were "tomorrow I paint." On leaving New York City for summer vacations in Maine, New Hampshire, or Rockport, I was plenty excited at the prospect of three whole weeks of painting. Sustained my interest? Are you kidding? I'm as interested today as I was the day I painted my first watercolor. When I'm not actually painting, I'm reading about art and artists or going to exhibitions, taking students on painting trips, or indulging in shoptalk with my colleagues. There is one thing I like to do almost as much as painting and that's growing vegetables. My small garden just outside the studio has given me a lot of pleasure between painting bouts. Even I can't think of painting constantly.

**What about influences: should the beginner beware
of being influenced by the work of other artists?**

Painters who say they have never been influenced by the work of others are lying. Everyone has been influenced at some time. It is when influence becomes imitation that there is danger. When an artist like Andrew Wyeth is popularized to the point where his work is known to every art student in the country, then imitation begins. Most are honest folk who have been swayed by Wyeth's popularity and financial success. Also it is only natural for a student to be influenced by a favorite instructor for a while. If the student is serious, the influence fades in time. As a student, my greatest influences were the French and American Impressionists who influenced my oil technique; the nineteenth-century English painters and the Americans John Singer Sargent and Winslow Homer influenced my watercolors.

**What would you recommend as a proper course of study
for someone just starting a career in art?**

One should be extremely careful in the choice of an art school. Many painters are what is called self taught. That is a very loose term. For instance, the art education of Whistler and most of the French Impressionists consisted of a rather slipshod attendance at what today we would call a sketch class, where they drew from life. At the same time they painted landscape from nature and out-

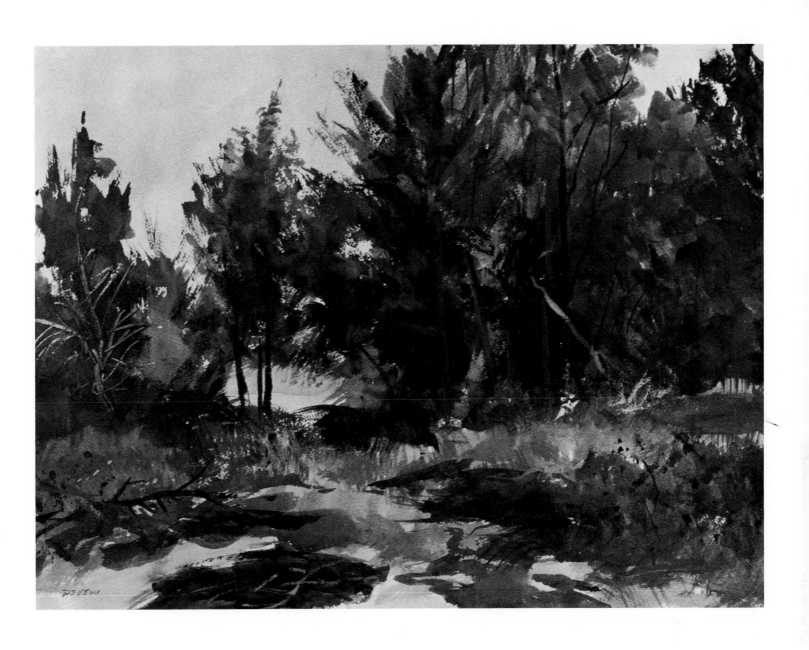

SUMMER TREES
Watercolor on paper,
11 x 14 in. (28 x 35.6 cm)
Collection Mr. & Mrs. John F. Dembeck.

Whenever I conduct an outdoor painting class in summer I always hear the old complaint about everything being so green. I agree the season does present a few color problems, but it never stopped John Constable or the French Impressionists.

I advise the students not to rely on prepared tube greens, but to mix a variety of greens with combinations of the blues and yellows they have on their palettes. I tell them to think about the character of the tree and worry less about its exact color. Raw sienna with blue is an old standby for mixing green.

door figure compositions using their friends as models. Then there were visits to the museums where the masters were studied and copied.

Rather than the big, impersonal art school, I suggest that study with a painter of some reputation, willing to teach a private group, would be more rewarding. Classes that work outdoors are the best bet for the landscape student. One doesn't learn to paint landscape indoors.

What are the rewards or satisfactions of being an artist?

The greatest reward is the approval of my work by fellow artists whose opinion I respect. Satisfactions? Well, it's satisfying to have paintings accepted and hung in some of the important exhibitions throughout the country. It was very satisfying to be asked to do this book. It is very rewarding to be represented in several museum collections. Living the artist's life is in itself rewarding even if I can't own a yacht or a Cadillac.

Are there any drawbacks? What are they?

If the artist has no private income, there are bound to be what some would call drawbacks. It might be necessary to work at some salaried position for several years, to live in a less affluent neighborhood than one would like—or to drive a secondhand car or none at all. If the painter is willing to pay for the privilege of being an artist, these will not seem to be drawbacks—believe me, I've been there.

What do you mean when you say, "Don't paint the obvious"? What is the obvious?

The obvious is what the average tourist photographs. It is subject matter that's been painted so often it has become boring. It is the subject that makes jurors exclaim, "Oh no, not again!" It's Rockport harbors, Motif Number One. It's San Francisco's Fisherman's Wharf. It's Irish thatched-roofed cottages, Dutch windmills, and New England covered bridges. Look for new subjects or, better yet, a new way of presenting the old so that they become your subjects. Be creative, not a copycat.

You say you don't care for sentiment or nostalgia in today's art, yet you admire many late-Victorian painters. Can you explain?

I believe an artist should be of his own time. Those old-timers I admire certainly were. Their paintings may seem nostalgic to us now, but that's due to the passage of time. They painted the people, the life, and the costumes they saw and experienced every day. This is also true of the French Impressionists—for instance, Renoir's *Le Déjeuner des Canotiers* or Degas's *Café Concert.* Today we have a

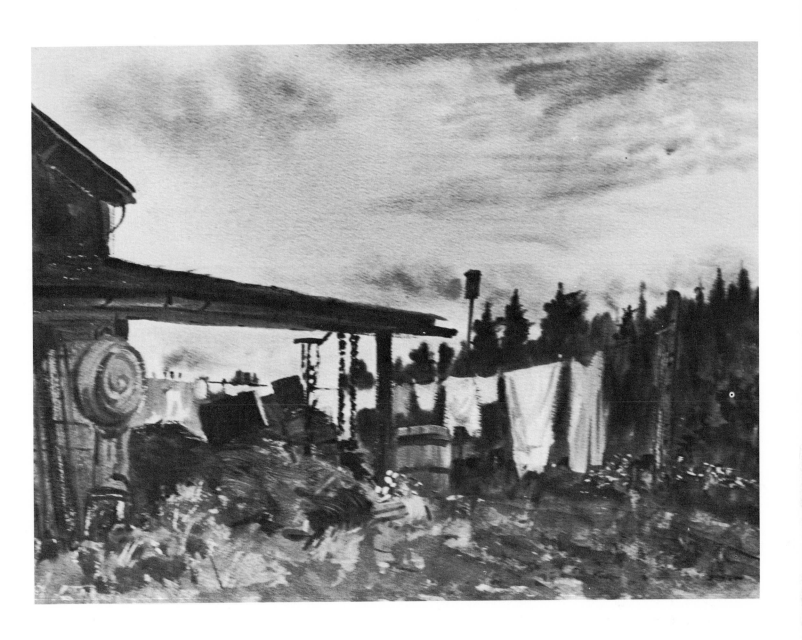

WILDERNESS WASHLINE
Watercolor on paper,
11 x 14 in. (27.9 x 35.5 cm)

The location is New Brunswick, Canada. We had been taken to visit a potter and his wife. I thought I might as well paint, while the ladies admired the potter's work. On walking around the back of the house this is what I found.

Thirty minutes at top speed and it was done. I just couldn't pass up this great material. I'm sure glad I took that walk out back. It was painted on 140 lb. Arches cold pressed watercolor paper with two round sable brushes, numbers 8 & 10.

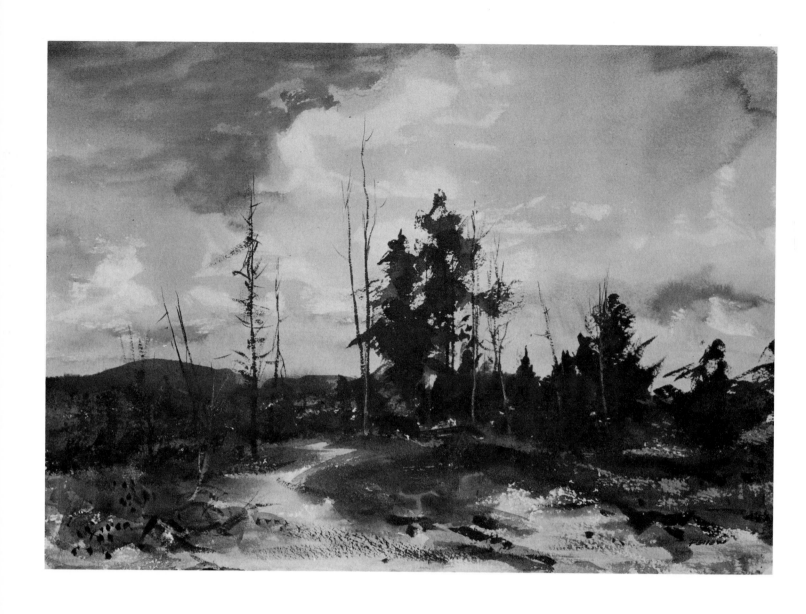

THE WEST WIND
Watercolor on paper,
22 x 28 in. (55.9 x 71.12 cm)

This was painted from a small sketch made near Twin Mountain, New Hampshire. I first painted the sky working as rapidly as possible. This is necessary when working outdoors because cloud patterns change rapidly. The distant hills went in next, clear across from left to right ignoring the trees. The third step was the foreground—notice the drybrush texture used here. The final step was the dark trees. A dark tone can always go over a lighter one. The light tree trunks were scratched out with my fingernail.

group of painters specializing in paintings of the American West. Many are very fine craftsmen, but they are painting a West they never saw. This brings us back to what is nostalgia. Well, when in the 1970s you paint Indians attacking a stagecoach—that's nostalgia.

Are there any other significant experiences you've had as a painter that you would like to share?

As I look back, I think the most significant experiences were: the evening I heard Robert Henri's last lecture; the year I spent on a committee with John Sloan for the old Independent Society; and being introduced to Charles Burchfield at the Rehn Gallery. Henri never knew I was in the audience and I never exchanged more than a dozen words with Sloan or Burchfield, but just being in the same room with those giants was to be on cloud nine. Call it hero worship—well, what art student isn't a hero-worshiper. It must be fifty years since Philip Yates took me to visit N. C. Wyeth in his Chadds Ford studio, but that morning is clearly stamped on my memory. I think I had better stop right here. This begins to sound like name dropping.

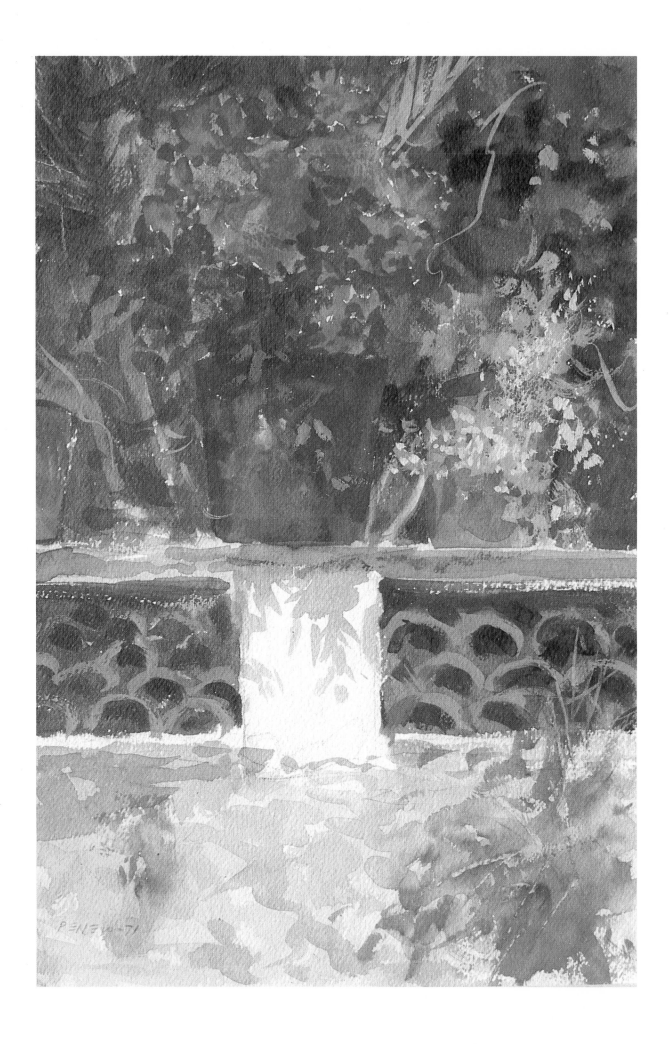

DEMONSTRATIONS

ON THE PATIO, TAXCO
Watercolor on paper,
15 x 11 in. (38.1 x 27.9 cm)
Collection of George and Dorothy Kaestner.

Along the wall on one side of the patio at Rancho
Taxco were several large clay pots containing gor-
geous colorful blooms. I had been busy all week with
a painting group, but on the last afternoon of my visit
I found time to do this watercolor. For me, it says
Mexico as well as any landscape I painted on that
trip. The brilliant sunlight, the cast shadows, and the
tropical color were truly exciting. I painted on cold-
pressed Arches 140 lb. paper with only two brushes, a
no. 8 and a no. 10, both round sables. It wasn't until I
had finished and had the picture in a mat that I real-
ized the subject was almost dead center in the picture
space.

A SALT MARSH

The best paintings of this subject were done by Martin Heade, who painted the marshes on the Massachusetts coast in the 1800s. At that time the farmers of what were called saltwater farms gathered the coarse marsh grass for their cattle. They built up haystacks on the marshes which seemed to fascinate Heade for they are featured in many of his meticulous luminist paintings.

I first painted these marshes about twenty years ago around Essex, Ipswich, and Gloucester. Except for the missing haystacks, they are the same now as they were in Heade's day. The marsh I have painted for this demonstration, however, is on the Connecticut shore on the road to Southport. Salt marshes are most common on a flat shore where fresh water from inland meets the saltwater of the ocean. As there are no distant hills or moutains, the marsh painters, if they are smart, will feature the sky. The marshes are beautiful to paint during all seasons but are probably at their best in the fall. This painting was done in late summer. I worked on illustration board with round sables, numbers 2, 8, 10 and 12.

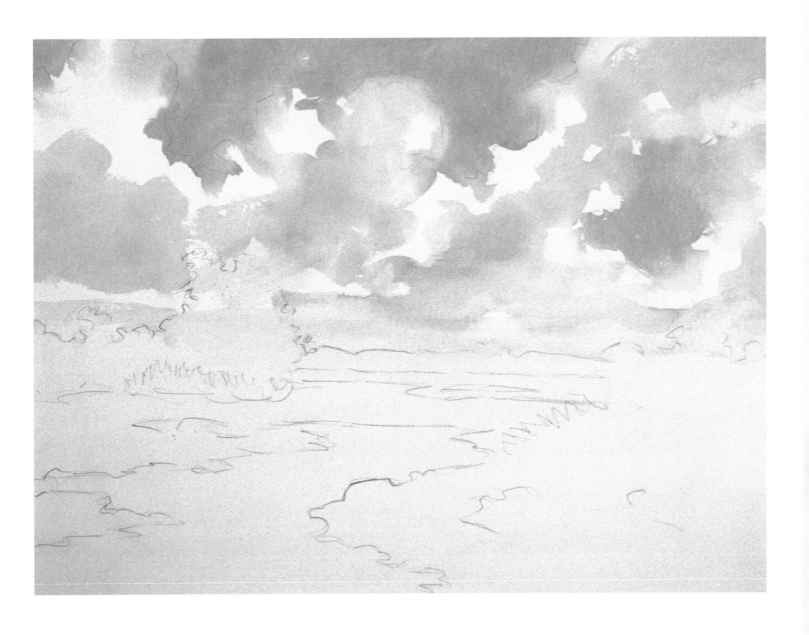

STEP 1. First I sketch the composition in pencil, placing the horizon below the center of the picture space, and thus making the sky larger in area than the landscape part of the scene. When composing, I try to have more sky than land or more land than sky, never an equal division of the space, or hardly ever. Next I paint a pale wash of yellow ochre over the entire surface. When the shine is off the paper and it's just damp, I rapidly paint the blue parts of the sky with phthalo blue. It's necessary to get the correct value here. Most students make it too dark or too light. The luminous shadow tones of the clouds are painted next. Using the same brush, a number 10, I mix some cadmium red light with what was left of the blue, then quickly paint the gray tone. Luminosity is easily killed by overworking a watercolor sky—so I called mine finished. When you paint a sky, it is foolish to keep looking up as the clouds race across the blue. The best, in fact, the only way to do it is to wait for a pattern that composes well, sketch it rapidly with your pencil, then paint it from memory. After all, isn't all landscape work memory painting? You can't look up and down at the same time.

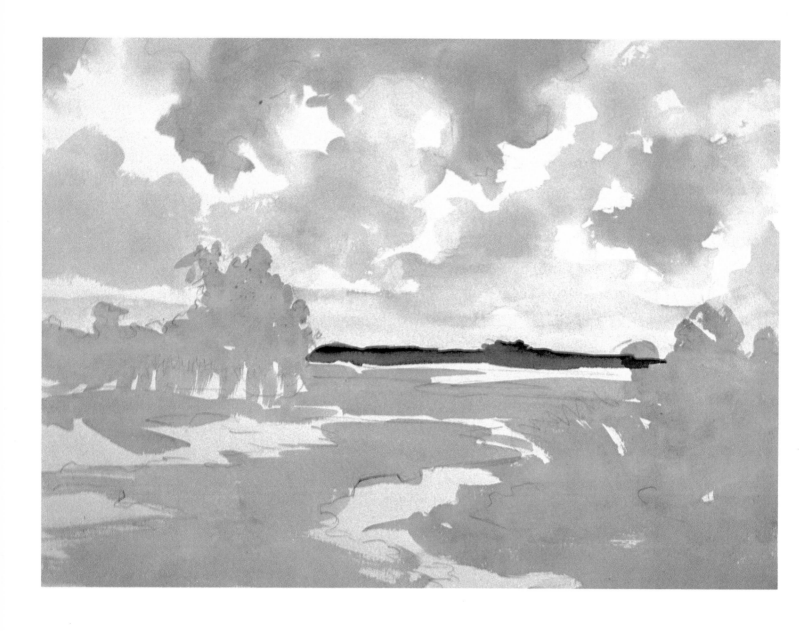

STEP 2. When the sky has dried, I put in the dark, cool color of the distant trees and land. For this I use a mixture of phthalo blue and a little raw sienna and paint with a number 10 round sable. Then, using the same brush, I painted the lightest tone of the water with a mixture of phthalo blue and cadmium red light. Allowing this to dry, I mixed a light green using yellow ochre and raw sienna with just a touch of phthalo blue, and painted it over the land and foliage areas, keeping the same number 10 brush. As with most of my watercolor landscapes, this one is painted from light to dark, with the darkest darks going in last.

I can't think of marsh painting without thinking of the English watercolorist Thomas Collier (1840–91). I've never met anyone in America who has heard of him and very few who did in England. He handled the medium beautifully and was well known in his time. I was lucky the day I found Adrian Bury's book on his work, which was published in 1944. Sorry about this digression, but I had to get old Tom in somehow and, anyway, I hadn't any more to say about Step 2.

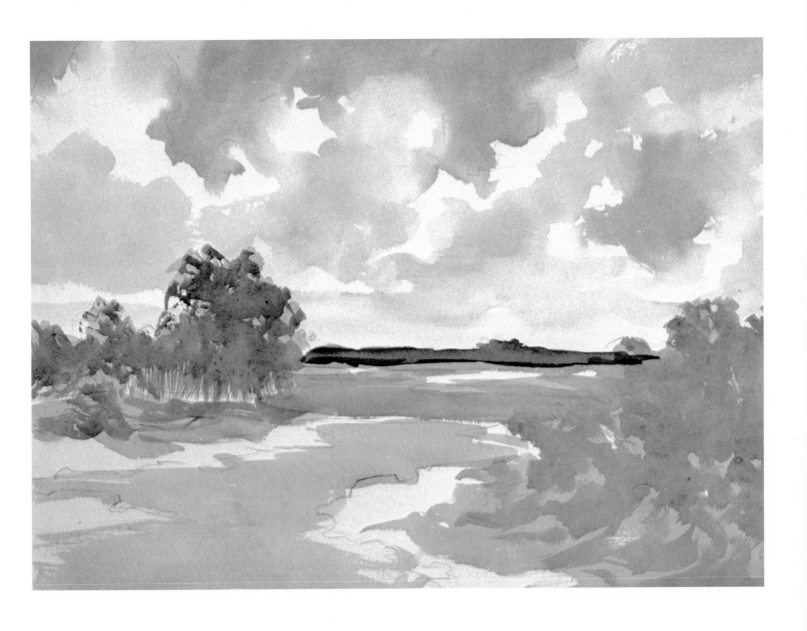

STEP 3. A morning spent on a salt marsh is an exhilarating experience. The wind driving the clouds across the sky and rippling the water is a subject made to order for the watercolor painting, as many have discovered. The next step in the making of this picture is to put some darker greens into the trees, weeds, etc. These are the middle tones; the darkest are still to come. The greens were mixtures of yellow ochre, raw sienna, and phthalo blue. I have no prepared greens on my palette, as I prefer to mix them with my yellows and blues as I work. Many students, when mixing greens that are not very dark, add too much blue, which results in a green that is lacking in warmth. Often a touch of burnt sienna will warm a green that otherwise would be too cold. This painting depicts a sunny, breezy day, not a hot one; therefore, although the shadowed parts should be cool in color, I don't want them to be too cold. I used brush numbers 8 and 10.

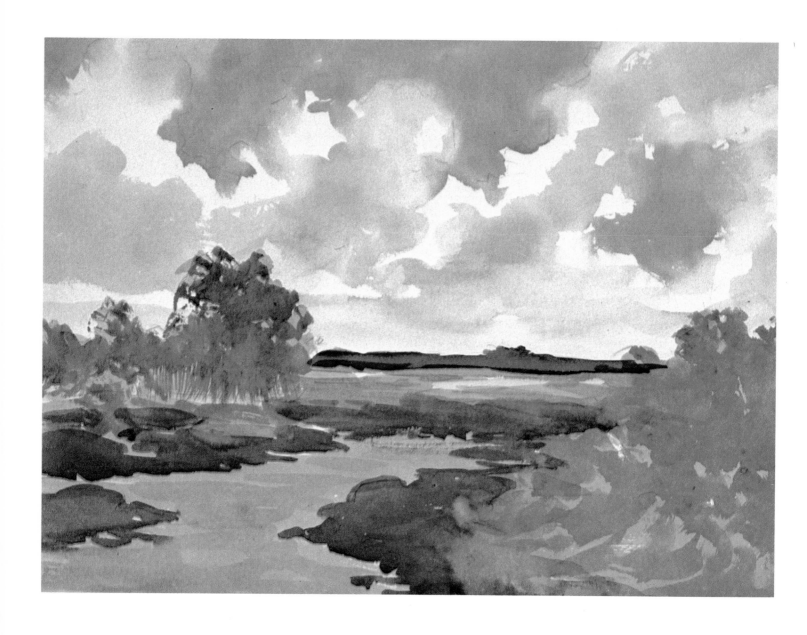

STEP 4. As the tide rises on this marsh, the mud flats at the water's edge are covered. In my picture the tide is not full; so some mud and rocks are visible. With my old reliable mixture of phthalo blue and cadmium red, I indicate them on both sides of the water. The mud that is constantly covered and uncovered by the water takes on a purple gray color for which my red and blue mixture is just right. I call it mud, but, actually, it's made up of mud, sand, broken shells, and decomposed seaweed. Next I add water to my puddle of mud color and then some phthalo blue, and put in some horizontal brush strokes on the water. These help create the illusion of a little movement on the water's surface and also keep the water on a flat plane.

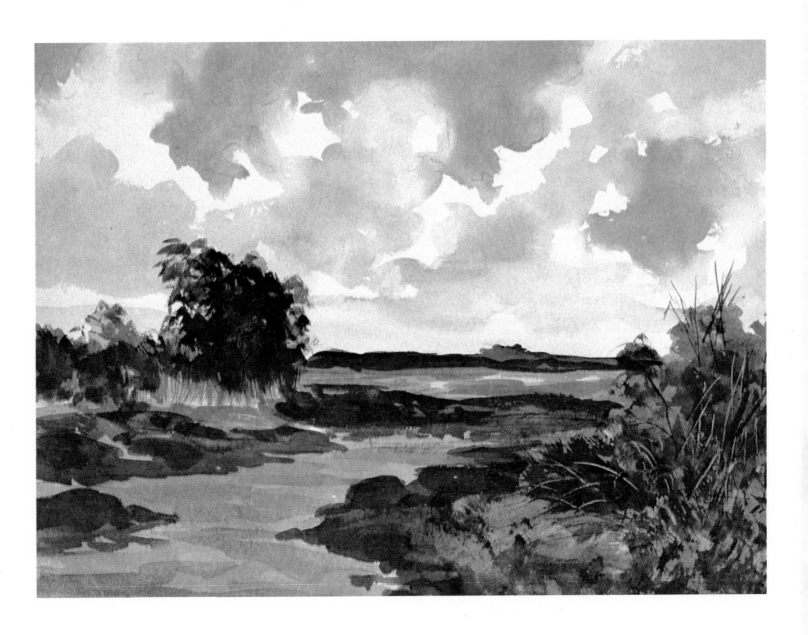

STEP 5. In the final stage the painting is given just enough work to suggest reality but not enough to compete with photography. This is the time to establish the darkest tones to give the rendering life with some strong contrast. I mix my darkest green with raw sienna, phthalo blue, and burnt sienna. This goes into the trees at the left, along the far edge of the water, and into the bushy right bank. I also go over the middle-tone greens to strengthen them in the center of the picture and in the bushes. The tall grass below the trees are rendered by spreading my number 10 brush, pressing it on the palette, and dragging the green downward over the light grass.

With a darker mix of the colors used for the mud, I go into the banks and with bold brushwork give those areas some variety and a suggestion of rocks. The weedy right foreground having dried, I dampen it with clean water using my one-inch flat brush. This allows me to scratch some lights with my fingernail. Using my well-worn number 2 brush and mixing a dark with burnt umber and phthalo blue, I put in the dark twigs, bringing some of them up against the sky. Some spatter in the lower right corner and the salt marsh is finished.

A ROCKY BEACH

In this painting I tried to capture the mood of a calm day on the coast of Maine. For that reason I chose a day when there was an offshore fog bank and very little movement in the water. This part of the coast has been beautifully described by Sarah Orne Jewett in her book *The Country of the Pointed Firs,* an American classic. When I see that fog bank on the horizon, I think of that wonderful line of Carl Sandburg's: "The fog creeps in on little cat feet."

Artists have been painting the Maine coast for many years. Winslow Homer is the best known, but there are many others including Rockwell Kent, George Bellows, Marsden Hartley, and Andrew Wyeth.

I endeavor to show the stark drama of the dark firs against a luminous gray sky, both of which reflect in the water. The cruel sharpness of the rock ledges below the trees and in the foreground are characteristic of the country. In the immediate foreground I suggest the rockweed that is uncovered by the receding tide.

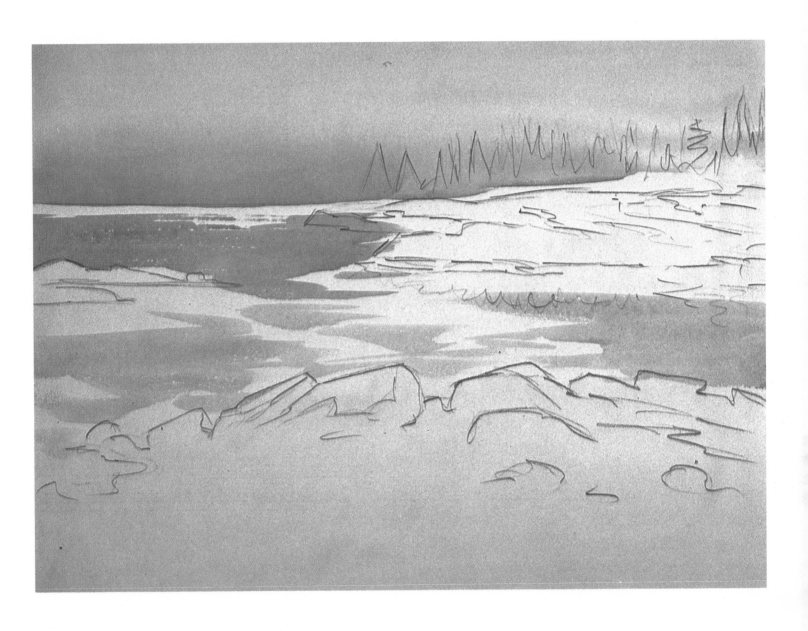

STEP 1. After sketching the composition in pencil, keeping the horizon well above the center of the space, I wet the sky with clean water, using a one-inch flat brush. I have already prepared a mixture of phthalo blue and cadmium red light. Now after checking to see if the shine is off the wet sky, I turn the paper around and paint the fog bank along the horizon. For this I use a number 10 round sable. Dipping the brush in clean water, I blend the fog into the damp sky area. This leaves a light tone over the upper half of my sky. Now, with the paper turned right side up, I give the ocean its first wash. For this I add water and cerulean blue to the mixture of phthalo blue and cadmium red light used in painting the sky. I leave a bold band of uncovered white paper along the horizon and some untouched shapes on the water closer to the foreground.

I often see that silver streak on the horizon in combination with an offshore fog bank—it's beautiful.

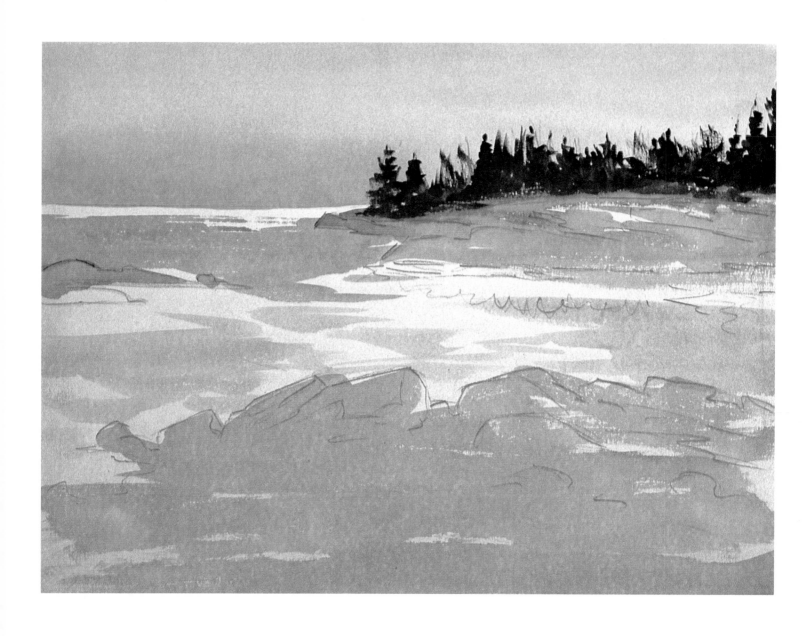

STEP 2. I put in the dark trees in the headland using a mixture of raw sienna and phthalo blue. Note the variety of edges where treetops are seen against the sky. Next I put in the warm green of the grass below the dark trees and then the lightest gray tone of the rocky headland, this same gray is used for the first wash on the foreground rocks, which is a mixture of burnt umber with a touch of phthalo blue.

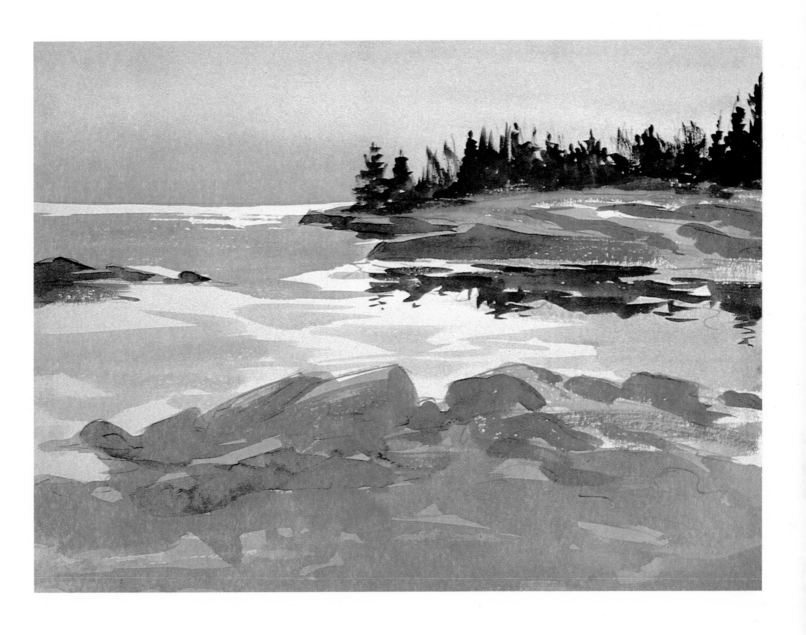

STEP 3. The gray mixture is also used for the rocks' middle tone. The green of the trees is used to suggest their reflections. In the foreground, which is a ledge covered in rockweed, I put in a warm wash made with a mixture of raw and burnt siennas and a little phthalo blue. At this point I hope I can pull the painting off without destroying its freshness and simplicity.

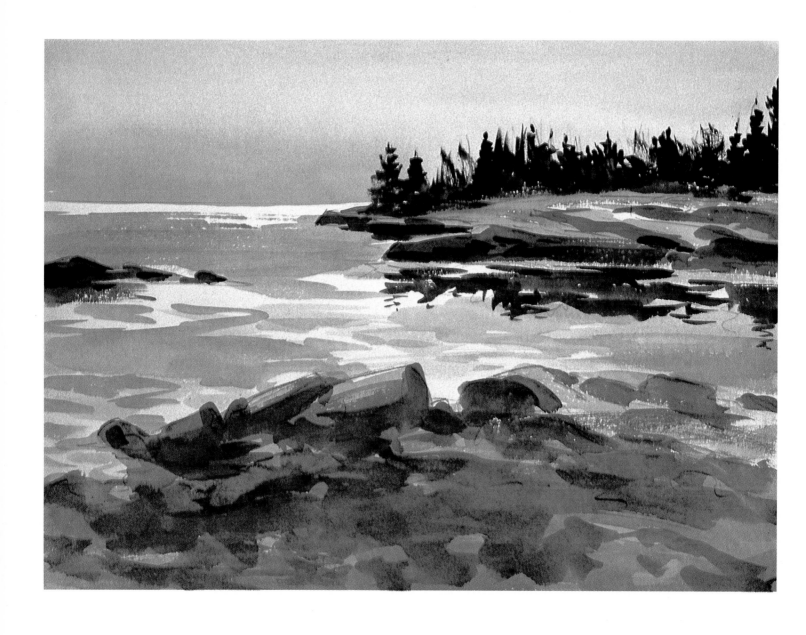

STEP 4. On the rocks of the headland I paint some dark green to represent the rockweed exposed by the falling tide. Next, working with phthalo blue, I work on the water with horizontal washes. Then, with the same green used on the rocks of the headland—a mixture of raw and burnt sienna with phthalo blue—I put some middle tones into the foreground.

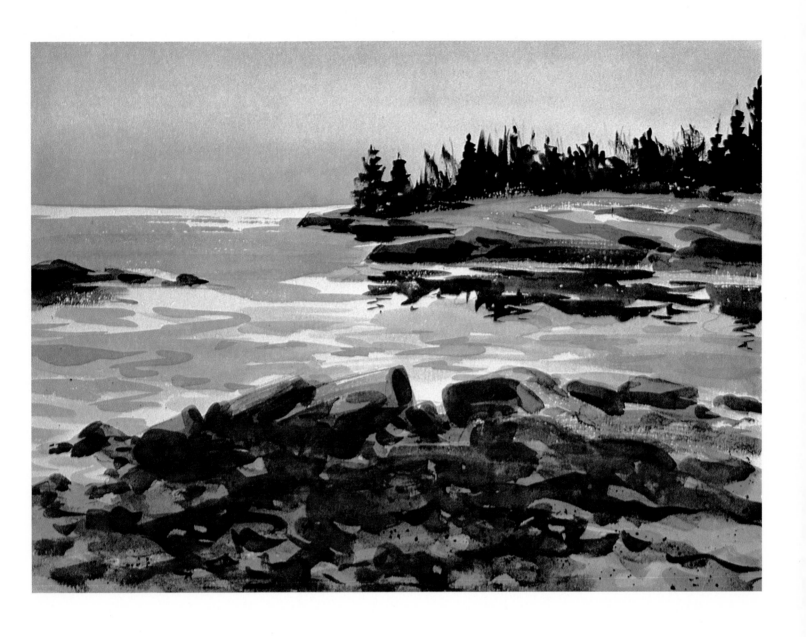

STEP 5. This step requires very little work. Perhaps it shouldn't have had any. Actually, I believe any watercolor can be painted in three steps. When carried too far, it becomes a bore. All I did here is to put in a few slightly darker strokes on the water and some dark brushwork and spatter in the foreground. The mixtures are as before.

MOUNTAIN STREAM

I have painted mountain streams in Colorado, New Mexico, and New Hampshire. They are all wild and rocky, but those in Colorado are the most exciting. The one pictured here is in that state, just above Georgetown. I have tried to show how the huge rocks that have fallen from the mountainsides have blocked the stream, forcing the water to flow around them. This almost creates the illusion of two streams, one from the left and one from the right, meeting in the foreground. In spite of this strange division of the picture space, I think my composition holds together because of the strong pyramid design of the big rock heap behind the water. The fallen log at the right also serves to direct the eye upward along the piled-up rocks. To show the movement of the swiftly running water, I use brushwork that follows the form or, in other words, the direction in which the water was flowing.

STEP 1. I pencil in a pattern of big shapes. When students tackle a subject like this one, they almost always take in too much. They hate to give up the sky, and create, as a result, a picture in which sky, forest, rocks, and water all compete and are all equal in interest. Feeling that my subject is the water swirling around the rocks, I eliminate the unnecessary.

I then separate the rocks from the water by giving them a wash of color that would serve as their lighter parts. This was simply a pale wash of yellow ochre. When this wash has dried, I mix phthalo blue and raw sienna to make a deep rich green and paint it around the top edge of the rocks and the fallen log at the upper right to represent the evergreen forest (completed in Step 4) seen beyond the rocky stream.

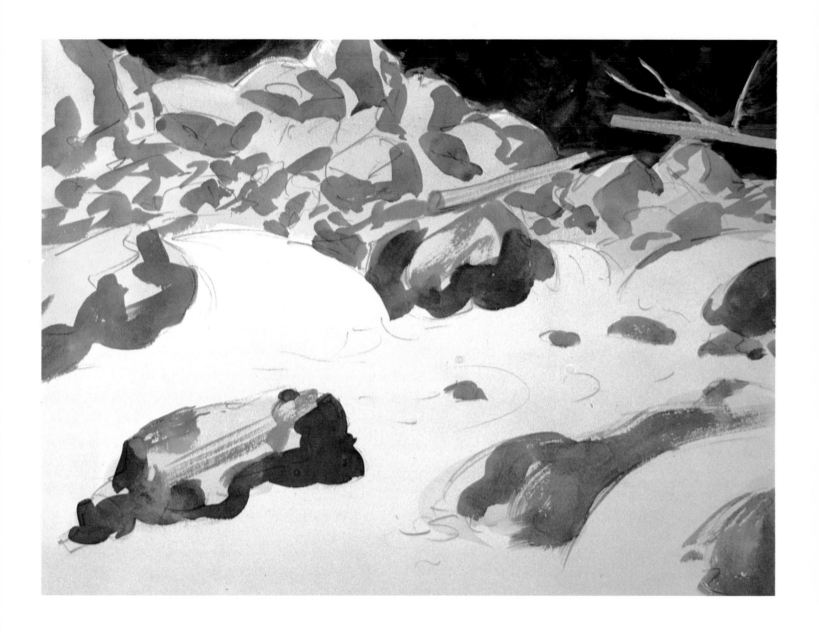

STEP 2. I begin to develop the rock forms with burnt umber. This is done boldly and freely with no attempt to make separate studies of individual rocks. In other words, one should not have a still-life approach to nature when working out of doors. By holding a strong top light, my rocks have, I hope, a feeling of solidity.

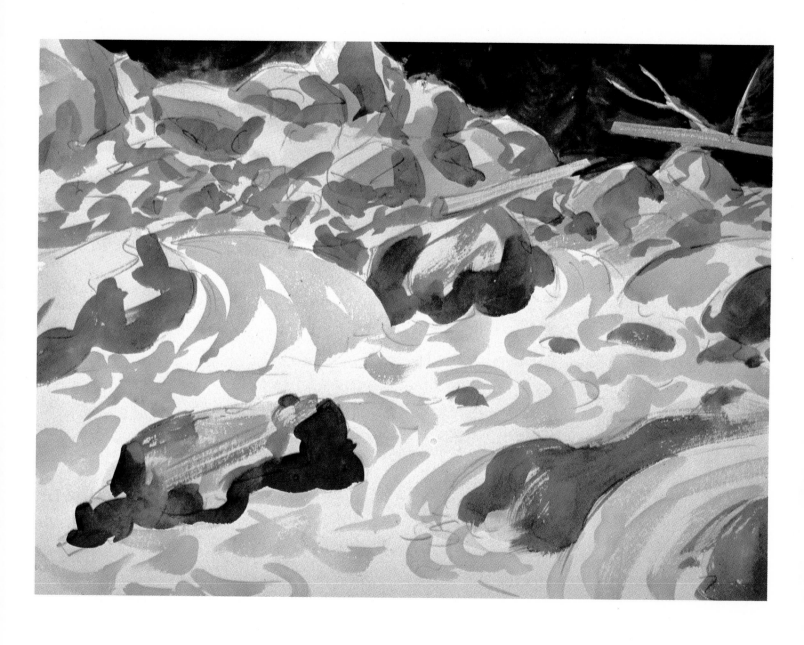

STEP 3. With phthalo blue grayed with a touch of burnt umber, I now use broad strokes of my number 10 round sable to indicate the direction in which the turbulent water is flowing. This rendering has to be as free and simple as the brushwork used in the rocks. I also put in some cool gray tones in the rocks using a mixture of phthalo blue and a little cadmium red light.

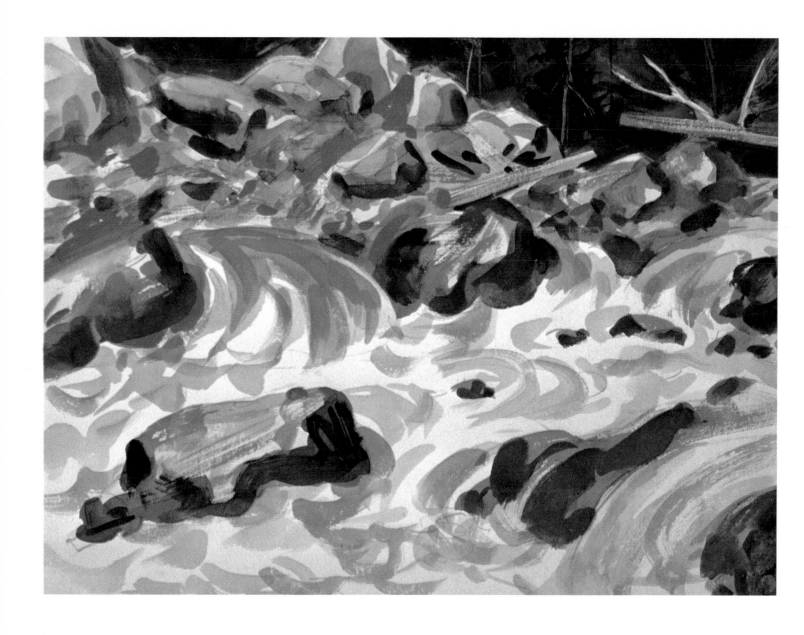

STEP 4. With some dark green—a mixture of phthalo blue and raw sienna—I work on the forest background just enough to suggest the distant trees. I also use a few fingernail scratches for trunks and dead branches. The rock forms are now strengthened with burnt umber.

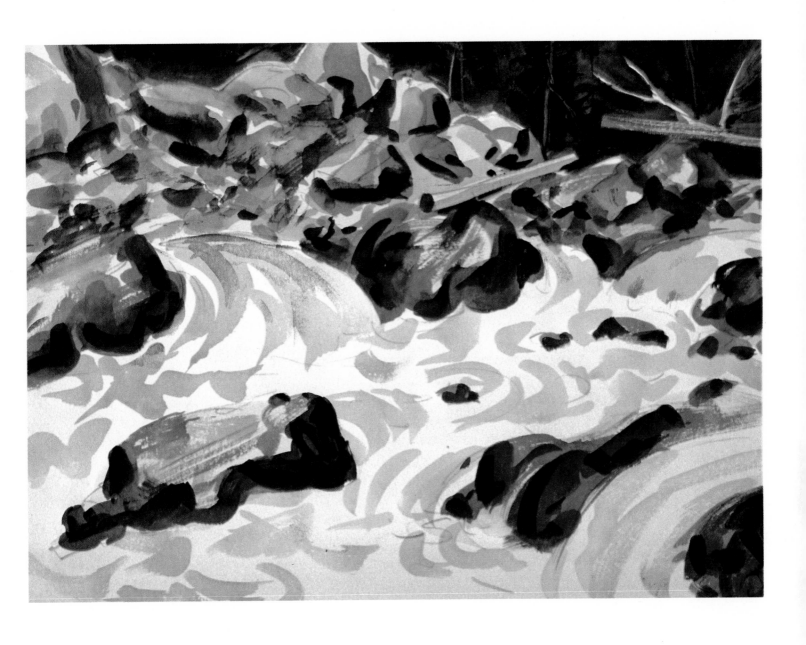

STEP 5. The darkest darks that occur in the rock pile are painted in with burnt umber. Using raw sienna, I add some warm color to the water. Then, after thinking what to do next, I decide there's nothing to do. An outdoor sketch can sure be ruined by staying with it too long—so I quit.

AUTUMN WOODS

In painting this picture, I use the same technique as I do in *A Woodland Caprice*, reproduced on page 93. As explained in the caption for that picture, it was an experiment that grew from my curiosity to see what could be done with powdered colors mixed with water and a little acrylic medium. Depending on how much water is used as a thinning agent while painting, the mixtures can produce both opaque passages and transparent washes. The resulting surface is more like pastel than watercolor and for that reason I spray it with fixative as a protection against smudging.

I make no claim for this as anything but an experiment on a rainy day. Experts on paint chemistry and processes used in the arts probably wouldn't approve.

In this picture I try to capture the glowing color of the October woods behind the studios of the Silvermine Guild of Artists in New Canaan, Connecticut, where I have often painted with my outdoor landscape class.

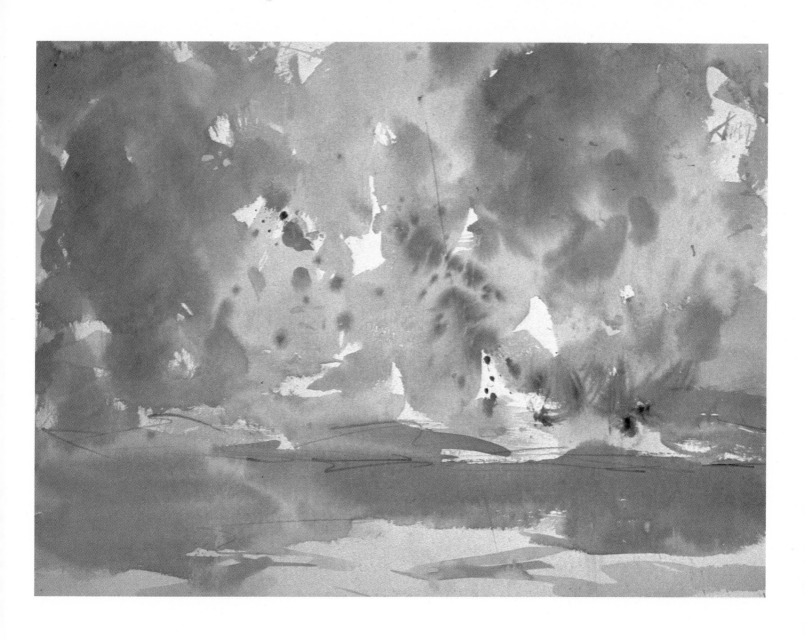

STEP 1. A few pencil lines to indicate the division of the space between trees and water—that's all the drawing needs.

Now I close my eyes and think of that quiet stream and the surrounding woods. I know it well; so with the image fixed in my mind, I start improvising with color. At this stage I use just some thin washes of warm color—cadmium red light, burnt sienna, and yellow ochre. This is just to tone the paper. I have no think-ahead plan for this picture, just a vision of the October woods that I hope will come through—and maybe, it will, maybe it won't. Hang on, we'll see.

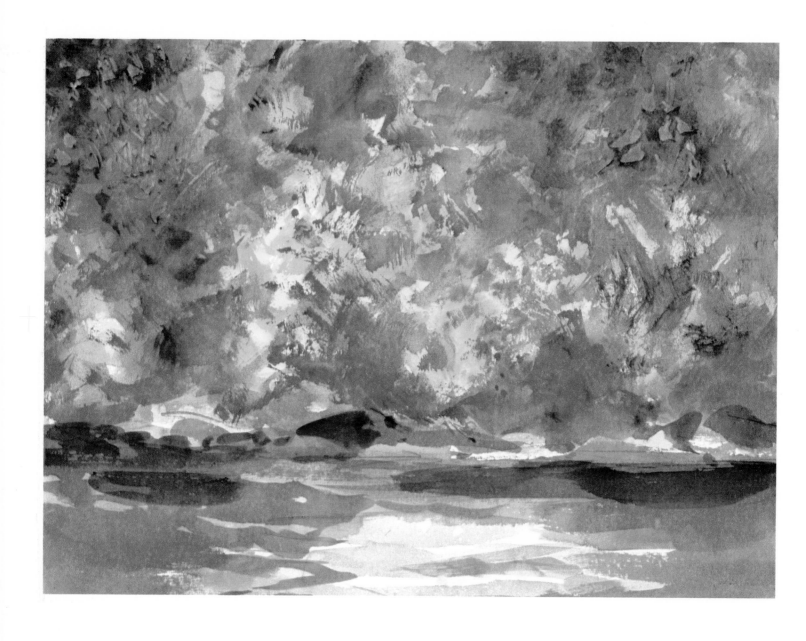

STEP 2. The subject begins to take shape. There's a suggestion of trees, rocks, and water. Here I used cadmium yellow light, yellow ochre, raw sienna, cadmium red light, and a little burnt sienna. In the tree area the colors are put in with both brush and palette knife and allowed to mix on the paper. Although I call this improvising, at this point I still know what I'm doing—trees, rocks, and water.

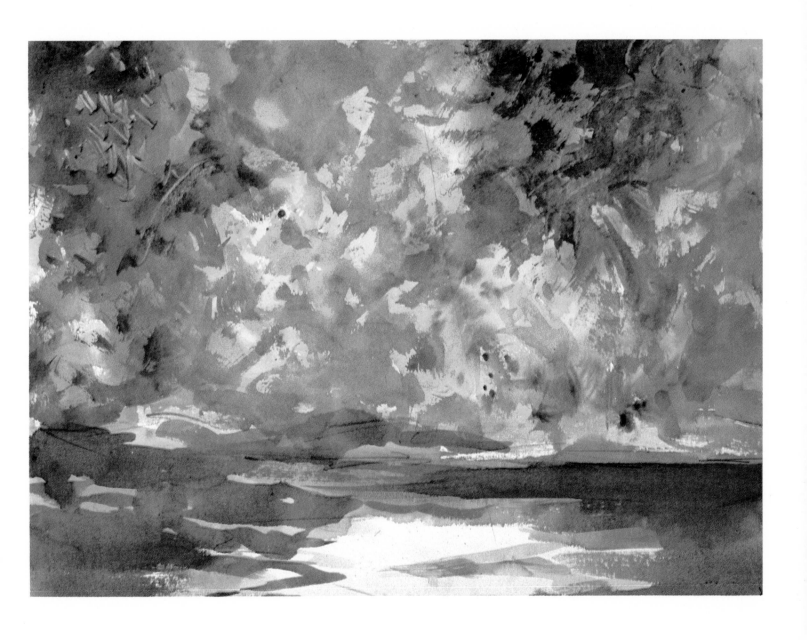

STEP 3. Some burnt umber and burnt sienna darks are put in the foliage with an old, well-worn, one-inch flat brush dragged and wiggled here and there. Another burnt sienna wash is used on the water. The uncovered area in the center foreground is given a wash of phthalo blue for the sky reflection. Then a few fingernail stabs are placed top left and right just for fun.

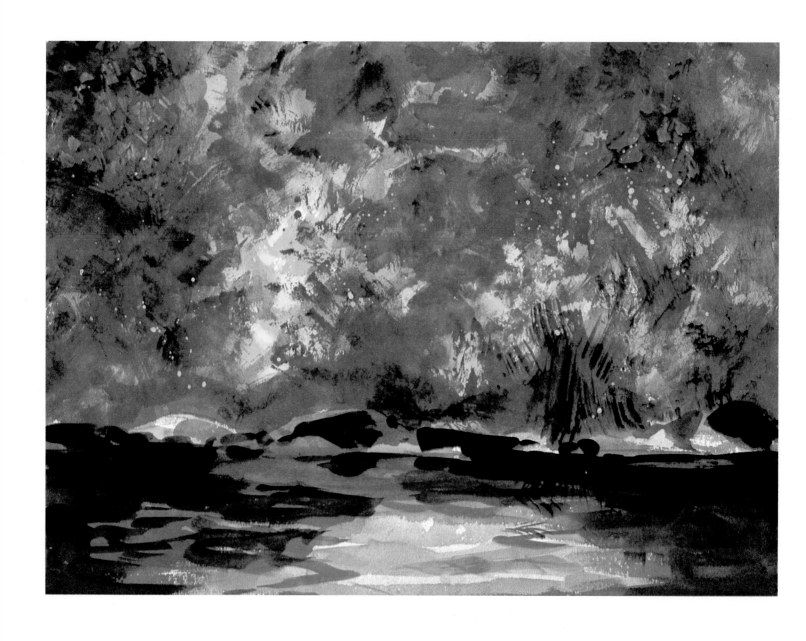

STEP 4. To have something to judge my tonal value pattern against, I put in a few definite darks, which are a mixture of raw and burnt siennas with phthalo blue. These colors can be seen in the rocks and also, in diluted form, in the foreground water. In the trees I scumble around with my one-inch flat again, then mix some cadmium yellow light with acrylic white and spatter some lights here and there. I am now ready to proceed with the final step.

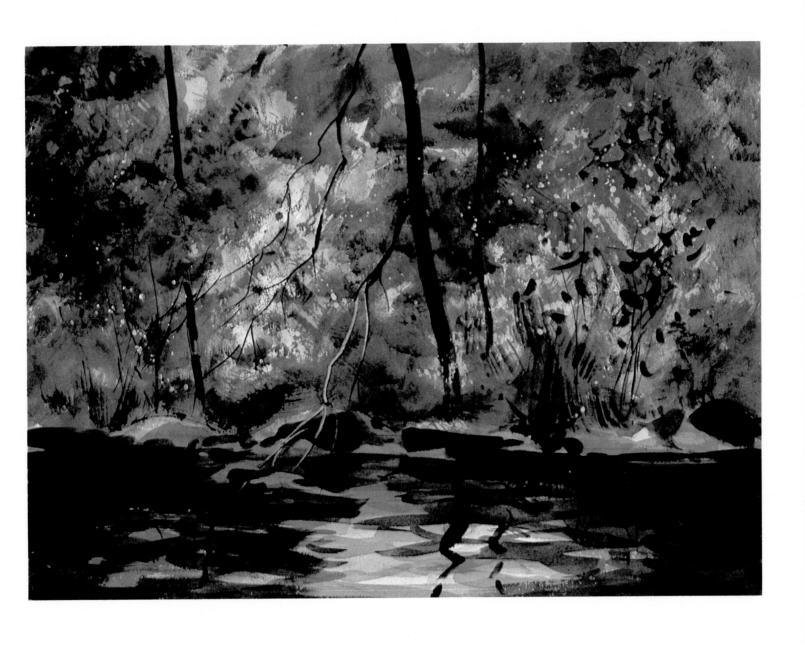

STEP 5. When I was just at the start of my watercolor career, I overheard a well-known old-timer say, "It's the last ten minutes on a watercolor that either makes or breaks it." I have never forgotten those wise words. Using all the colors used in the previous steps, I go over the trees and water once more. I put in one dominant tree trunk, then some smaller ones and a suggestion of branches. More light spatter and some darker phthalo on the blue sky reflection and I'm finished.

A SNOW SCENE

I paint this picture in the comfort of my studio, looking from the window across the snow-covered lawn. My vegetable garden, a joy in spring and summer, would be seen in the left background if it hadn't been under two feet of snow at the time.

Here I have tried to create the mood of the bright sunny days we experienced after the big snow that came our way in '78. I like snow paintings and have often suffered to produce them in the field. The opportunity to do this from inside was too good to miss. Snow is beautiful but also a damn nuisance.

I have always found snow paintings done in America more interesting than those painted in Europe. It may be that the light here is more dramatic, less soft. The group of painters now known as the American Impressionists painted some great snowscapes in the 1920s. The best were Edward Redfield, George Bellows, Rockwell Kent, and the grand old man of Rockport, Aldro Hibbard.

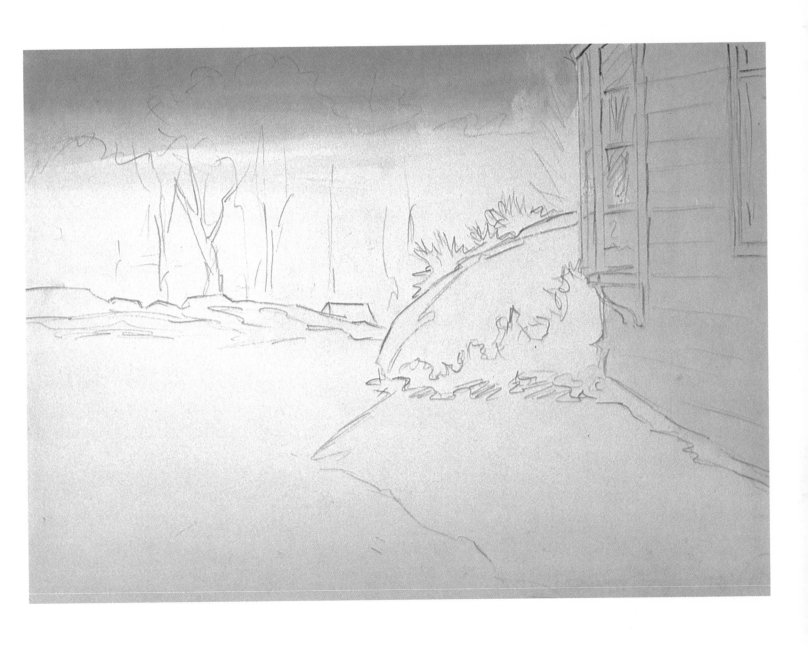

STEP 1. Composition is an arrangement of shapes on a flat surface. It is a very important part of picture making. In this first step my composition is lightly sketched with an HB pencil and then a couple of color washes are put in. The blue represents the sky and is straight phthalo blue thinned with water. The pink tone on the side of the house is an underwash over which a cool color will be superimposed at a later stage. The cast shadows on the snow facing up to the blue sky will be cooler in color than the shadowed vertical side of the house. That's the reason for the pink wash. I hope that's clear.

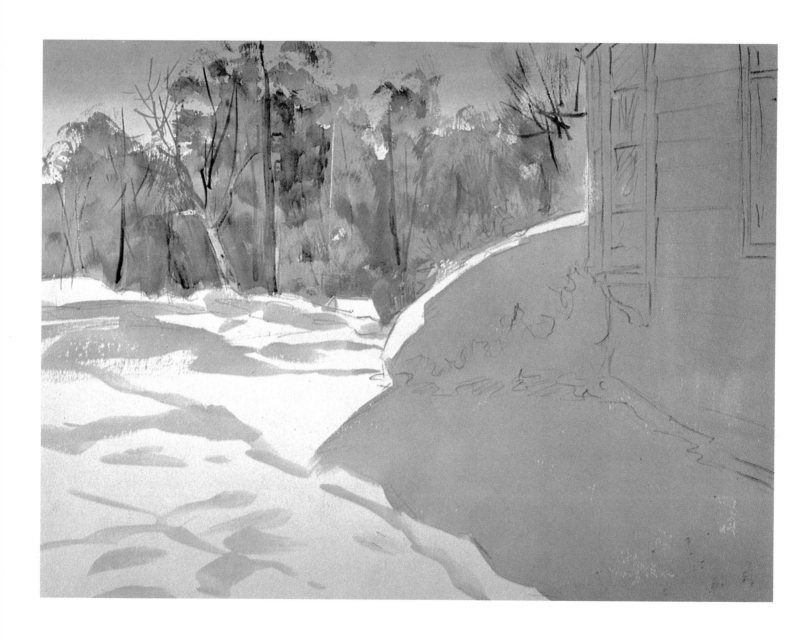

STEP 2. With this picture I demonstrate what I have already said: It is almost always possible to paint a complete watercolor in three steps. In this second step I use a wash of phthalo blue, with just a touch of burnt umber in it as a toner, to go over the side of the house and to establish the cast shadows on the snow. I then paint the warm tone of the sunlit woods in the background, keeping them quite simple. First comes a burnt sienna wash into which I drop some phthalo blue while still wet. Then comes some fingernail scratches, a few dark lines with a rigger. I use burnt umber for this and for the dry-brush in the treetops.

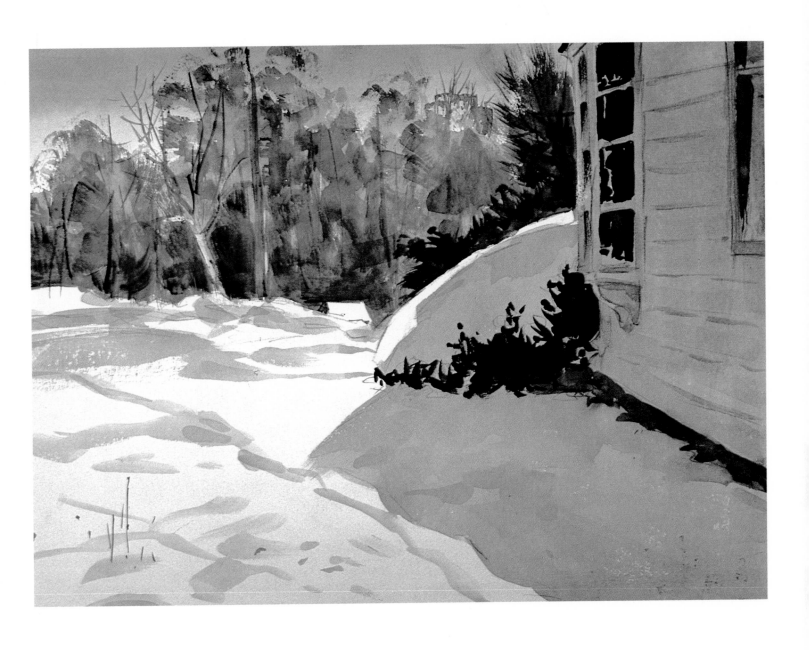

STEP 3. In the final ten minutes I add the necessary darks to the house and snow-covered bush and strengthen the shadow areas. I go over the wooded background with some more burnt umber dry-brush. The dark green of the bush is a mixture of raw sienna and phthalo blue. I use burnt umber and phthalo blue in the window. Here is a simple, direct, realistic statement. Why elaborate? More work wouldn't make it any better; it might even make it boring.

THE DESERT

Doing this demonstration brought back memories of a happy day we spent with good friends in California. Fred and Eileen Whitaker drove us from La Jolla to Borrego Springs where we had a delightful lunch. The kind of scenery we saw along the way was all new to me. There was no time for painting, but I had the old secret weapon along, so I shot a few color slides of several interesting spots. Two of the photos, with some help from my visual memory, were used in painting this demonstration.

I wanted to capture the big openness of the desert country, plus the brilliance of the prevailing light. The flatness of the desert floor stretching away from the foreground to the distant base of the mountain range was intriguing. To establish the perspective and the illusion of depth, while at the same time making a simple watercolor statement, was a challenge. What I feel does it is the contrast of the lightest sunlit area with the dark line of the distant trees and those two close-up bushes in the foreground. It was fun doing this while a blizzard raged outside my Connecticut home.

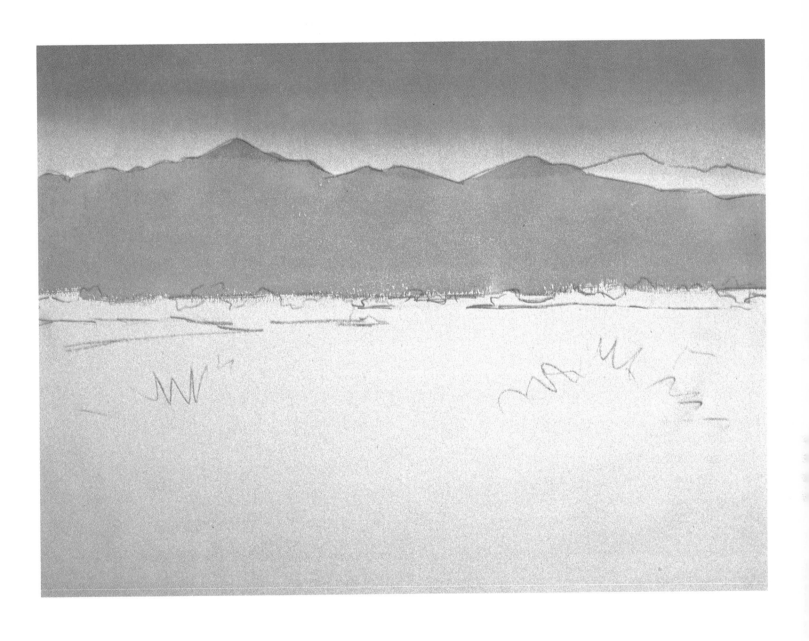

STEP 1. After sketching the composition lightly in pencil, taking care to make the main shapes—i.e., the sky, the mountains, and the desert—different in size, I wet the sky with clean water. I blot up the excess water and paint the sky with a graded wash of phthalo blue, adding water as I come down to the top of the mountains. I had already decided just how I would render the warm lights and cool shadows of those mountains. It would be a superimposed wash of cool over warm, one of the oldest techniques known to watercolorists. As soon as the sky is dry, I paint the mountain range with a flat wash of a mixture of cadmium red light and cadmium orange. There is no attempt to model the form of the mountain at this stage; that would be done with the cool color to come. The warm color is not painted on the distant mountains seen at the right because cool color there would be used to create an illusion of depth or recession.

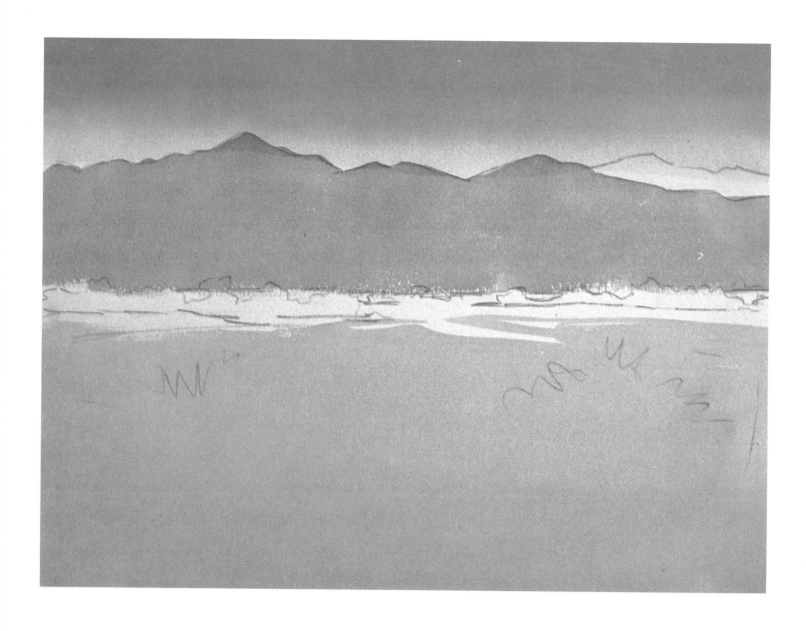

STEP 2. While the mountain range is drying, I start work on the desert. Its lightest value is just below the foot of the mountains and toward the center of the picture. I decide to leave that area untouched for a while; it could be toned down later. Over the rest of the desert, using a one-inch flat brush, I paint a wash made with a mixture of yellow ochre and cadmium orange. This is to be the second lightest value of the desert floor.

As this is drying I spend the time thinking just how I will keep the desert simple, yet give it character and perspective. It could be done with diminishing shapes and brushwork, I thought. It will have to be, because the air is so clear and the sun so bright it couldn't be done with tonal values that are quite dark in the foreground and becoming lighter as they recede into the distance. So on to the next step.

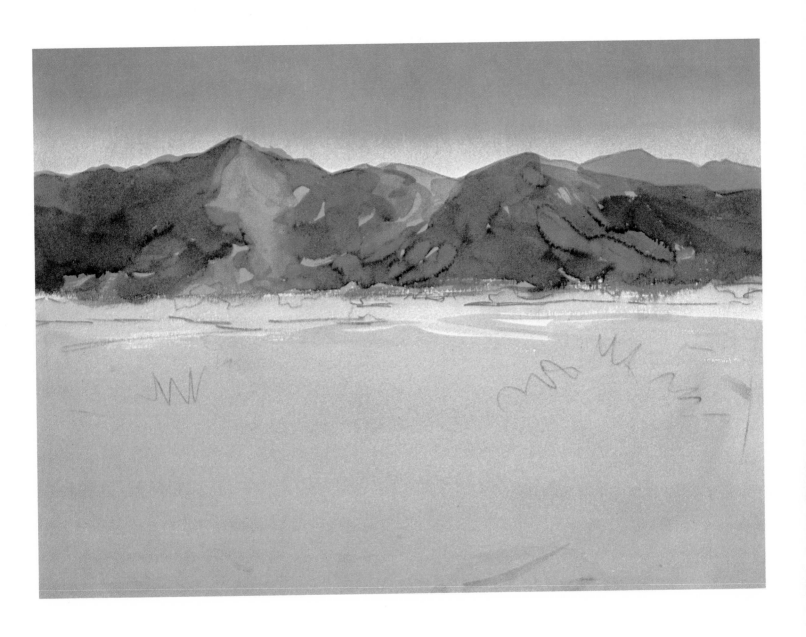

STEP 3. My bright red-orange mountains have to be taken care of before I can do anything with the rest of the picture. So, mixing a puddle of phthalo blue and water, I proceed to paint the first cool wash over the mountains. The strength of this wash is seen in the distant mountains at the right which are put in at this time. In the center of the mountain range I lift some of the blue wash with a squeezed-out damp brush. Keeping the solidity of the forms in mind, I try to suggest that the light source comes from the right. When you are painting a superimposed wash, it is important to work rapidly with as large a brush as can be handled comfortably. If this isn't done, the underwash could be picked up, resulting in muddy color and a loss of transparency. During the drying I tone the area that has been left white, using cadmium yellow light. I work with a number 10 round sable throughout this step.

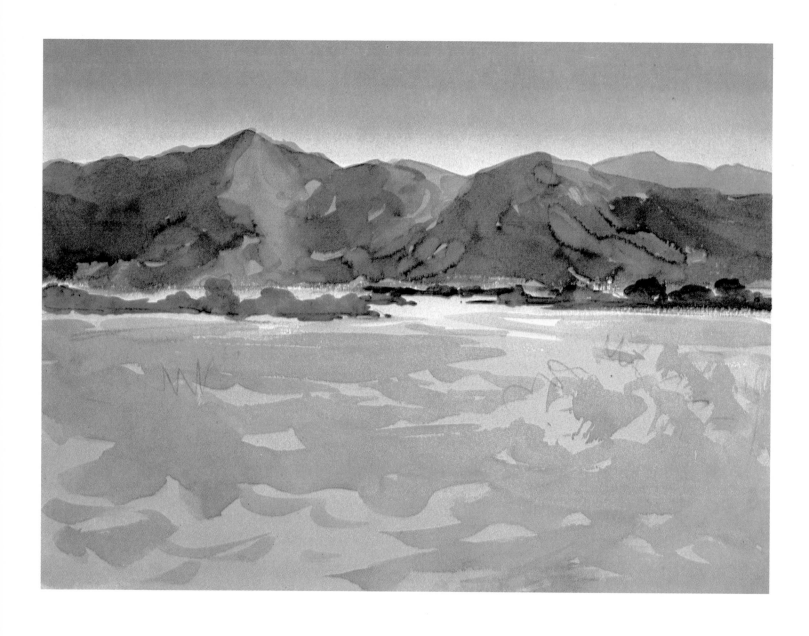

STEP 4. The dark trees at the base of the mountains are put in next. For these I use mixtures of raw sienna, burnt sienna, and phthalo blue. This last I find to be a very useful color for obtaining darks, although many students complain that it is difficult to control, saying it gets into everything. It is a powerful staining color; but once you learn to handle it, there's no doubt it's a blue of many uses. It is the only blue used in this demonstration. Notice its variety, for instance, in the sky, distant mountains, the main range, and the dark trees.

Next, I put down the middle tones of the desert. These are mixtures of cadmium red light, cadmium orange, and burnt sienna. I use horizontal strokes because I believe the direction of the brushstrokes should follow the form of what is being painted.

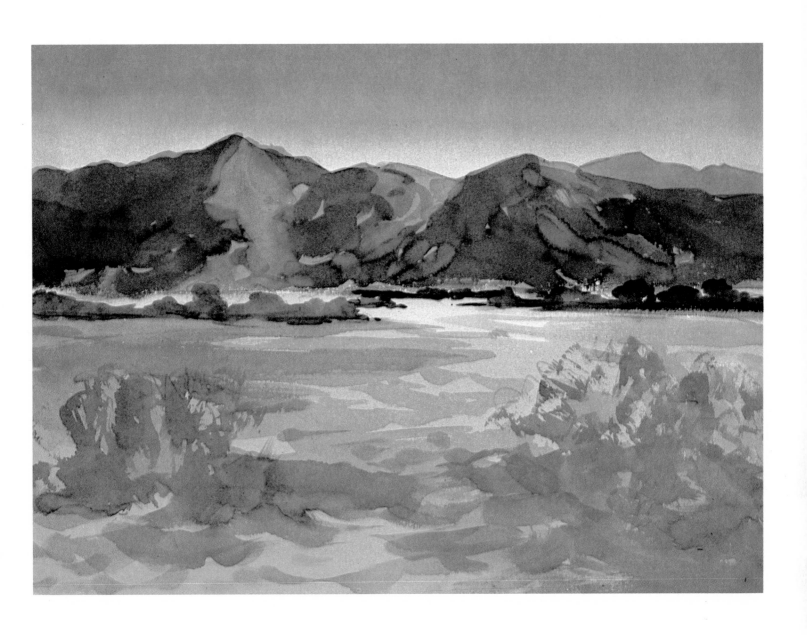

STEP 5. I start to develop the foreground and the bushes with a darker mixture of the colors used for the desert's middle tones in Step 4. In the foreground I use large strokes and quite warm color. These large brushstrokes suggest that this part of the picture is closer to the viewer than the more simple brushwork further back. Also, the reason for the warmer colors is that warm color appears to advance. This is easily seen if the warm color is compared with the cool blue of the distant mountains. Cool color creates the illusion of recession. In landscape painting a good rule to keep in mind is: cool color and lighter tonal values in the distance; warm color and darker values in the foreground. Of course, this applies only to a realistic approach, not to decorative or abstract painting.

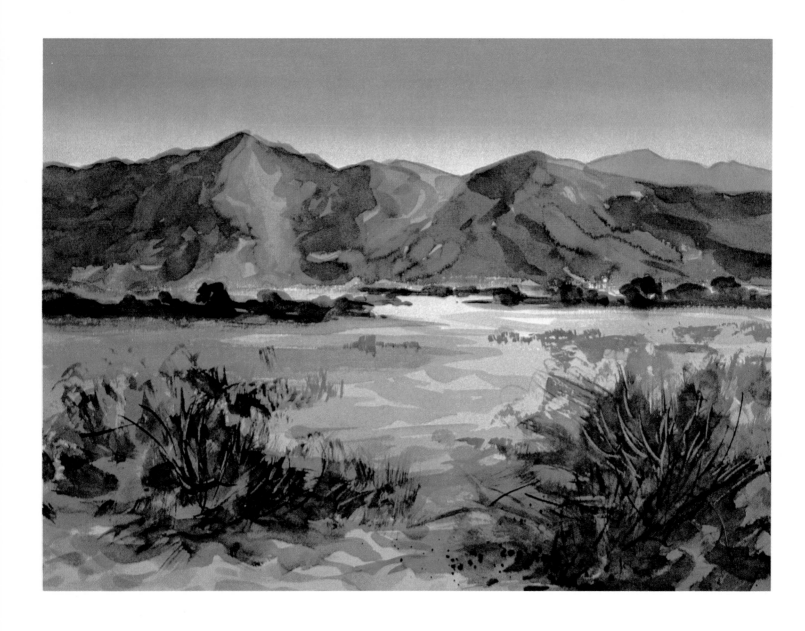

STEP 6. This is the final step. Now with phthalo blue toned with just a touch of cadmium red light and using my number 10 round sable, I develop the darker tones on the mountains to suggest more clearly the character of that magnificent range. I soften some of the hard edges with a squeezed-out damp brush.

I next give the bushes and the foreground my attention again. I use the same mixture of cadmium red light, cadmium orange, and burnt sienna but add more of the last. I also use some cool color to suggest shadow tones. For this I use the old reliable phthalo blue. For the twiggy parts of the bushes I mix phthalo blue and burnt umber for the darks and use my fingernail to scratch out some lighter twigs. The thin dark lines are done with a number 2 round sable, and some dry-brush, with an old number 10 stabbed at the paper. This is seen in the right foreground. Along the right bottom edge there is a little spatter for variety.

ONE-MAN SHOW

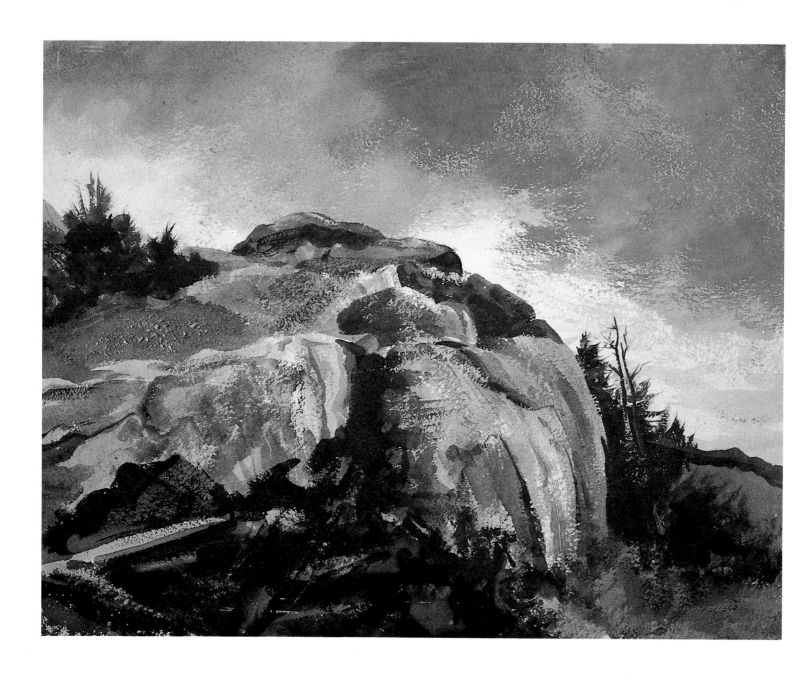

SUMMIT ROCKS
Watercolor on rough paper,
22 x 30 in. (55.9 x 76.20 cm)

Years ago when Elsie and I used to hike the trails and climb the rocks of New Hampshire's White Mountains, I took a lot of black-and-white photographs for souvenirs. This picture was painted from one. However, it doesn't resemble the photograph much. There was a lot more country in the photo, and perched on the top most rock was a large building, a fire lookout complete with tower. Also, from the left four hikers approached the tower. I have often told my students that what you leave out is as important as what you put in. Here I have taken my advice and the picture is better for it. The interesting textural qualities in the sky and rocks are due to the extremely rough paper. The manufacturer sent me this 300 lb. sheet as a sample. I thought it too rough for general use but found it worked well for this subject. I painted in four colors—burnt umber, burnt sienna, raw sienna, and phthalo blue; and used only large sable brushes, a one-inch flat and a number 12 round.

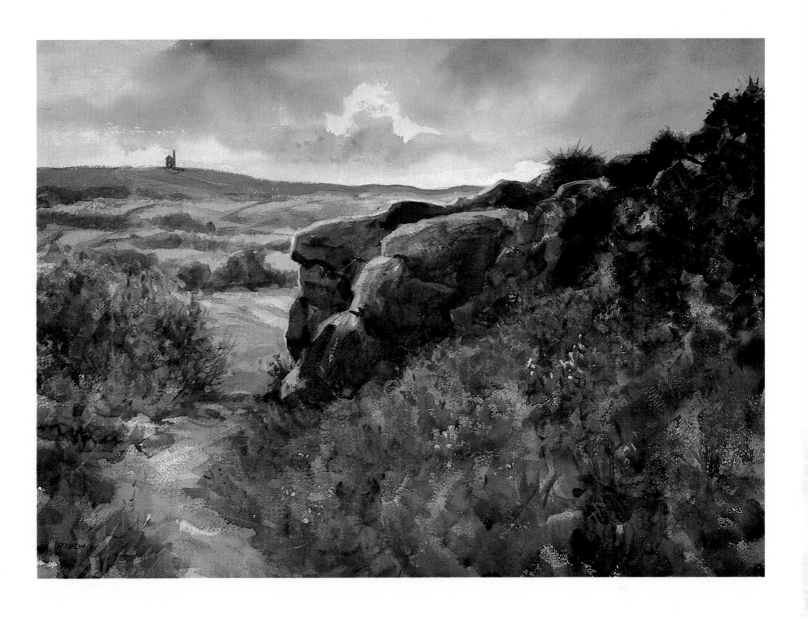

CORNWALL

Watercolor on paper,
22 x 30 in. (55.9 x 76.20 cm)

Artists who paint in Cornwall seem to paint its magnificent coast more than any other part. I, too, like the cliffs, the harbor, and the fishing villages; but, being a native, I know the other Cornwall as well—the moorland covered with bracken, gorse, and heather, and the little patchwork fields and derelict tin mines that dot the landscape. I think one gets a better feeling of this ancient place when inland rather than on the coast. This is a painting of the country looking west from above the village of Madron. On the skyline can be seen the ruined engine house of Ding Dong mine, one of the oldest and deepest in Cornwall. The time was a summer afternoon; the subject was backlighted. The illusion of depth or recession was created by the use of cool color in the distance and warm color in the foreground. The rocks were given solidity with a strong top light and shadowed sides. Cool shadow tones were painted over a variety of warm colors in the foreground. A few opaque lights were put in last to suggest wild flowers. The mine stack seen from the other side also appears in my *Acrylic Landscape Painting*—a Watson-Guptill book now in paperback.

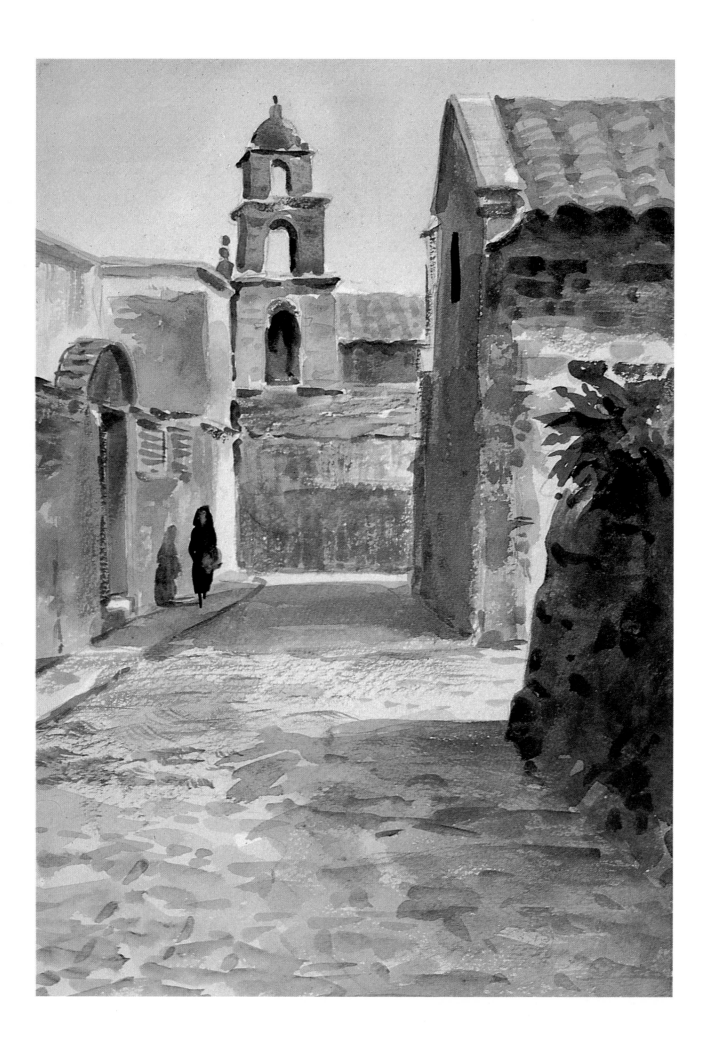

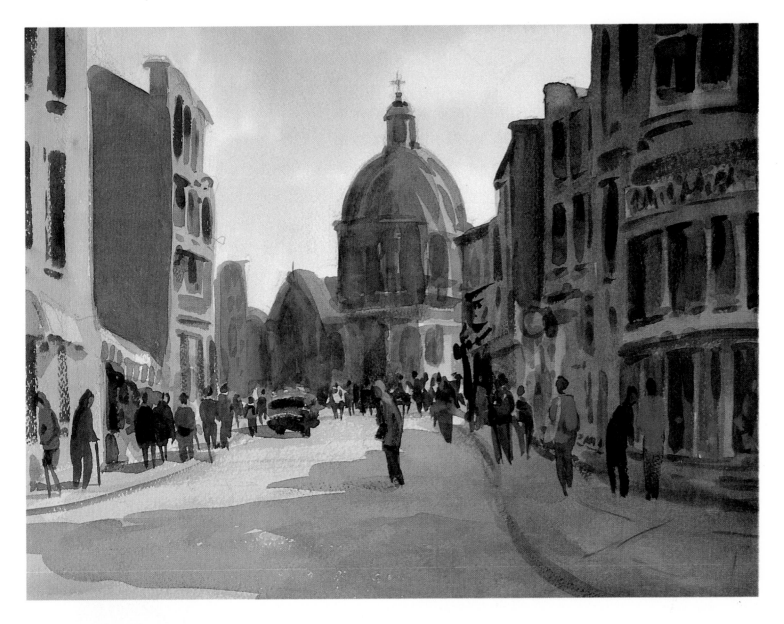

A QUIET STREET (left)
Watercolor on illustration board,
7½ x 11 in. (19.05 x 28 cm)
Collection Mr. and Mrs. Joseph Chickvary.

Before going to Mexico, I was told I would enjoy painting the colorful multilevel streets of Taxco. If I could have done so in peace and quiet, I would have enjoyed it very much, but the crowds of tourists and the Mexican children with their hands out for coins made the center of town impossible. Getting away from the crowds, I found a quiet back street. Sitting in the shade of a high garden wall, I was able to work for an hour, undisturbed. The eighth sheet is excellent for travel sketches of this kind. I use it often. The Mexican lady rounded the corner just at the right time. She makes a great focal point. I first painted the sky, a pale wash of phthalo blue. The rest of the composition was then painted in warm colors. When this was quite dry, I superimposed the cool shadow tones allowing the warm undertone to gleam through. This is traditional transparent method. I used two brushes, numbers 8 and 5 round sables.

PENZANCE (above)
Watercolor on paper,
10 x 13 in. (25.4 x 33.02 cm)

No, I didn't sit in the middle of one of the busiest streets in my hometown to paint this picture. I took a photograph and from it I painted a watercolor, but not this one. I wasn't happy with it. It was tight, too photographic, and the figures were not compositionally well placed. I put the photograph away, made a pencil sketch from the painting, and painted watercolor number two from the sketch. I simplified the detail, used a freer brushstroke, and placed the figures where they would do the composition the most good. When painting from color slides, it's easy to get trapped into imitating the camera. It's important to remember that it's the personal style of the artist that makes a painting interesting. A skillful copy of a color slide only proves you are a skillful copier. There is no record of Gilbert and Sullivan ever having been in Penzance. They just borrowed the name for their operetta. However, Spanish pirates were there in 1595. They burned the town.

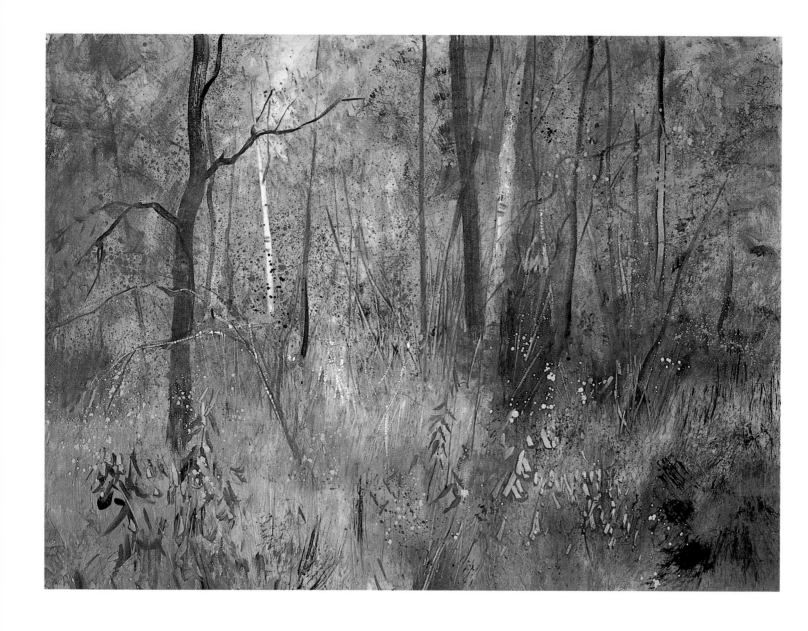

WOOD INTERIOR
Acrylic watercolor on illustration board,
22 x 30 in. (55.9 x 76.20 cm)

This is another of my dry-color paintings. I call them that even though water is
used as a medium (as explained in caption for *A Woodland Caprice* on page 93).
I was somewhat disappointed with this one. I would have liked it to be more
abstract, less naturalistic. I feel it's middle of the road, not one thing or the other.
Yet many disagree with me, finding it a pleasing woodland scene. As long as I'm
being critical of my own work let's go a bit further. I like the right side, from the
edge of the page to the tall dark tree. It's nice in color and technique. On the left
side I like the tree and the weeds below it. I guess it's the middle section that
bothers me. It's a big nothing and, being framed by the two dominant trees, be-
comes an eye-trap where there is nothing to please the eye; it is also difficult to
get away from. Never be afraid to be critical of what you do. A satisfied painter
is a hack painter. These woods out back will be there for me to try again when-
ever I am in the mood, and I will be.

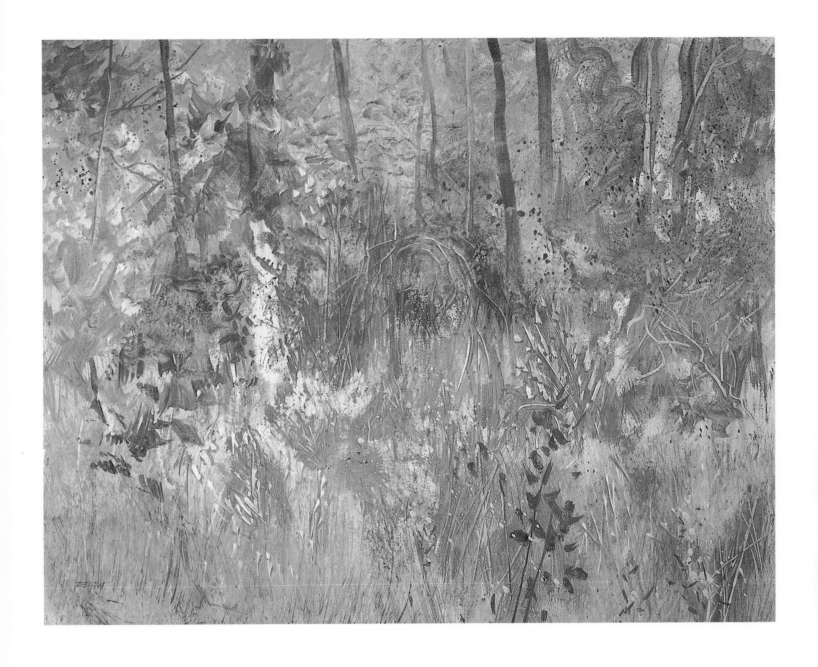

A WOODLAND CAPRICE
Watercolor on paper,
22 x 30 in. (55.9 x 76.20 cm)

When it rains, or sometimes as a change of pace, I work in the studio. It is then that I do my memory paintings which are mostly of woodland subjects because these are what I see more than any other. This painting could be called a fusion of memory with imagination. It also represents the first time that I used a different painting technique. In the studio I have jars of dry pigment that I grind with oils for inside work in that medium. I wondered how they could be used for watercolor. Setting out some mounds of the dry powdered pigments, I made them into a paste by adding water to each mound and mixing with the palette knife. Then to each color I added a few drops of acrylic mat medium to act as a binder. I then proceeded with the painting, using water with bristle brushes, razor blade, damp paper towel for blotting, and fingernails for scratch-outs. When dry, the painting had a pastellike quality. Just to be safe, I sprayed it with a fixative and framed it under glass.

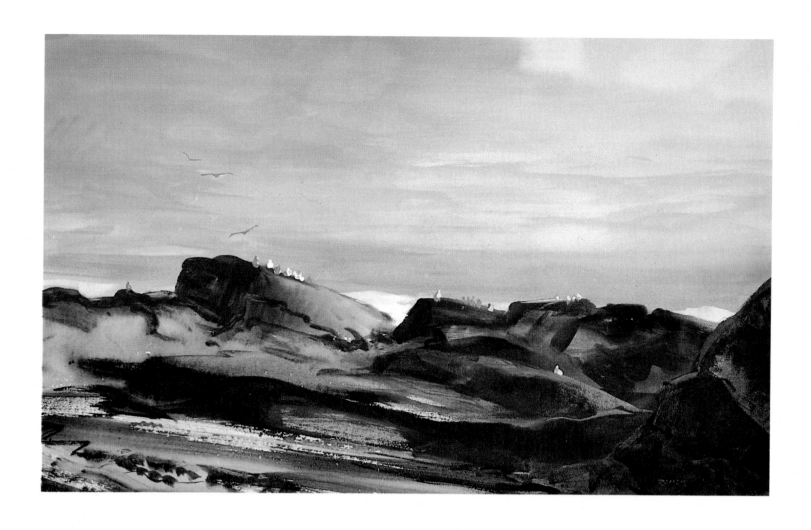

GULLS AT BASS ROCKS
Watercolor on paper,
15 x 22 in. (38.1 x 55.9 cm)

This rather simple statement was painted from memory after I had viewed the subject some hours earlier. It was that great teacher Robert Henri who said, "The good thing about painting from memory is that so much is forgotten." I feel sure I would not have painted the rocks as simply if I had worked on location. This is a big-brush transparent watercolor, except for the birds for which I used some opaque white. The sky and rocks were rendered with a one-inch flat sable brush. This picture being older than most in this book, I'm sure I used Payne's Gray for the cool tones in the sky and the darks in the rocks. I have not used that color for several years. I found it gave me rather sooty darks and stained the palette and brushes. Burnt umber and phthalo blue are the other colors used here. This is one of my first Bass Rocks pictures. Since then, I have done many paintings of the coast between Gloucester and Rockport.

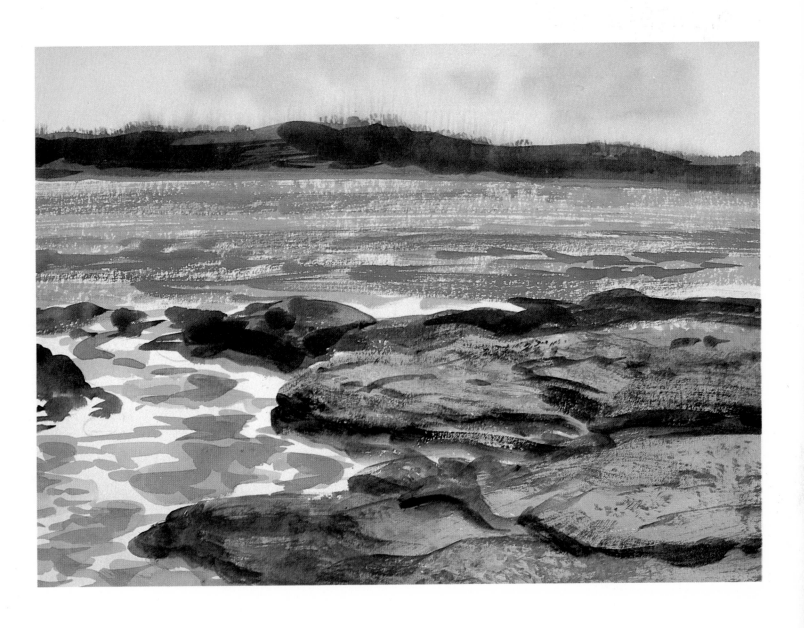

CLEAR DAY, COLD BREEZE
Watercolor on illustration board,
10 x 14 in. (25.4 x 35.6 cm)

This painting depicts a tidal inlet on the Maine coast. The long narrow peninsulas that make up much of this state's coastline, are like the fingers of the human hand. I have explored most of them and have yet to find one that fails to yield a number of paintable subjects. There are lonely farmhouses and weathered barns that must have picturesque nostalgia for the painter. There are salt marshes, at their colorful best in the fall. But best of all there are the rock ledges and the Atlantic Ocean. I think it is important to establish the mood of the day in outdoor sketches. What I hope I have achieved here is a feeling of a cold, breezy day, with the wind ruffling the water and an almost white sky, and a feeling of loneliness. There are no figures, not even a bird—yet this is not an unpleasant picture.

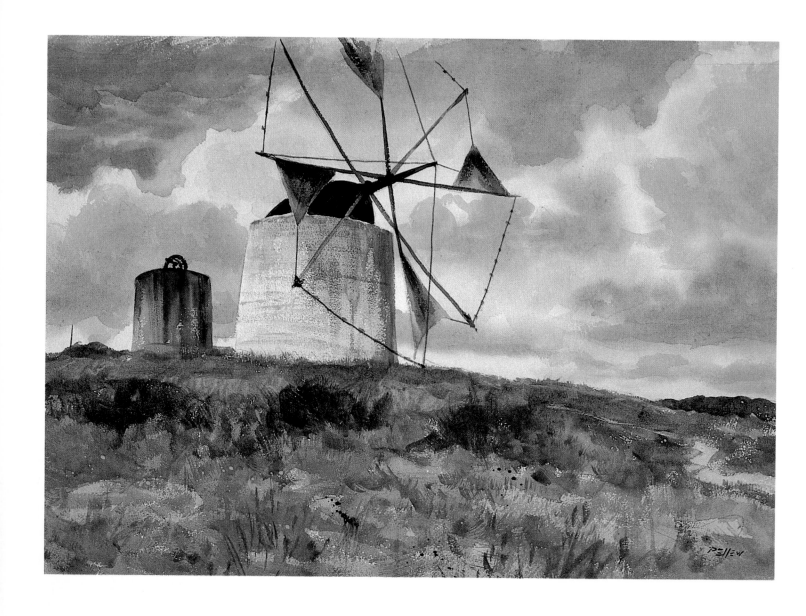

WINDMILL AT ERICEIRA
Watercolor on paper,
15 x 20 in. (38.1 x 50.8 cm)

All artists who go to Portugal or Greece feel they have to paint the windmills. I was determined not to do this. However, when I saw them, I had second thoughts, as this picture testifies. I still think windmills are the picturesque equivalents of our covered bridges, fisherman's wharves, and weathered Vermont barns—in other words, the obvious. I have more to say concerning this on page 46. I think what attracted me more than the mill itself was the gorgeous sky. Those swiftly moving clouds occasionally revealed flashes of brilliant blue sky, creating intriguing shadows on the ground. The foreground has a lot of my favorite raw sienna in it, also yellow ochre, burnt sienna, and phthalo blue. The colors used in the sky are cerulean and phthalo blues, and cadmium red light was combined with the blues to obtain grays. Note the dry-brush texture on the mill. My brushes were round sables—a number 5 for the small details and a number 10 for the rest.

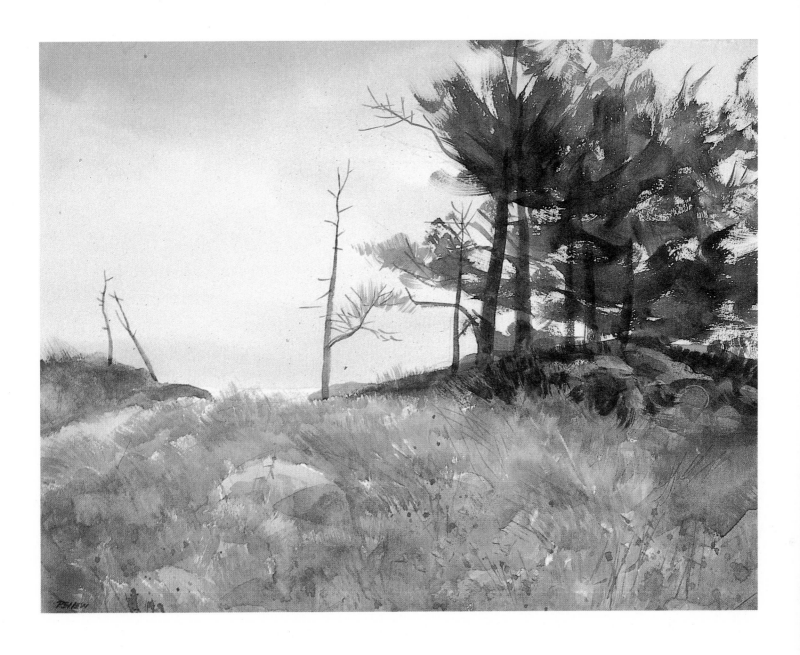

AT OCEAN POINT
Watercolor on illustration board,
10 x 14 in. (25.4 x 35.6 cm)

I painted this watercolor on a September morning when the dark Maine pines were in silhouette against a pale gray sky. I try to use as few colors as possible when working on location. My limited palette for this picture was yellow ochre, raw sienna, burnt sienna, and phthalo blue—four colors. If we count burnt sienna as a red, we have red, yellow, and blue. Almost any landscape can be painted with that combination. The foliage of the pines is a mixture of raw sienna and phthalo blue. I find that particular blue most useful for obtaining dark tones. For the tree trunks and the rocky area below the trees I used mixtures of burnt sienna and phthalo blue and in the gray sky, yellow ochre and the same blue. To capture the autumn color of the foreground grasses, I used yellow ochre and burnt sienna with some shadowed areas obtained with what is called palette gray. This gray is made of several colors that have run, or been scrubbed, together on the palette as the work progressed.

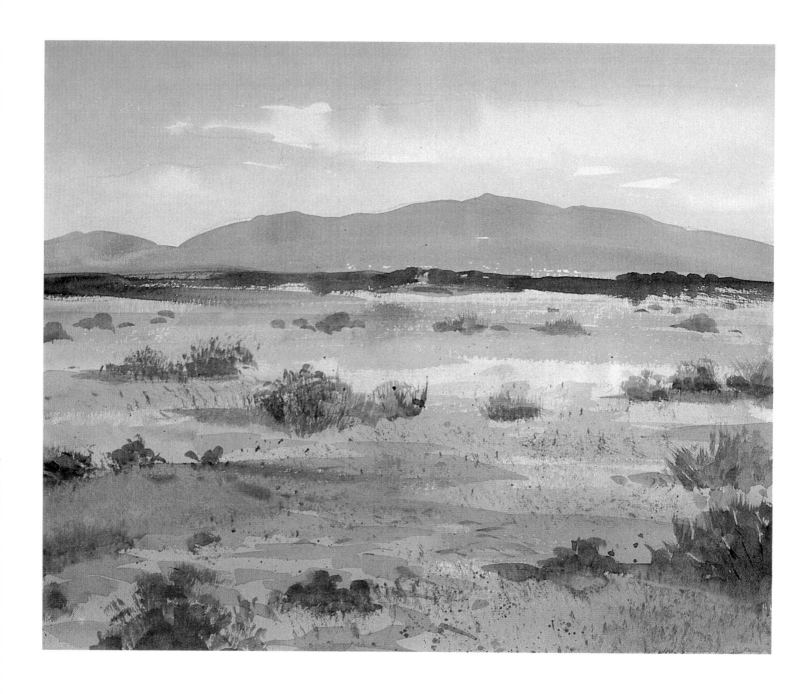

ABOVE THE RIO GRANDE
Watercolor on illustration board,
10 x 14 in. (25.4 x 35.6 cm)

Very early one morning we headed out of Taos for the desert above the Rio Grande gorge. We cooked and ate breakfast at sunrise, then painted the distant Sangre de Cristo Mountains seen across the colorful flat expanse. I started with a pale wash of yellow ochre in the sky. While this was still damp, I put in the phthalo blue, leaving the underwash for the clouds. The mountains are a mixture of cerulean and phthalo blues. The washes on the desert area are cadmium yellow light and just below the dark tree line, cadmium orange and cadmium red. A phthalo blue and alizarin crimson mixture was used for the darker tone in the foreground and phthalo blue with raw and burnt siennas for the distant trees. The sagebrush and foreground spatter are mixtures of burnt sienna and cerulean blue.

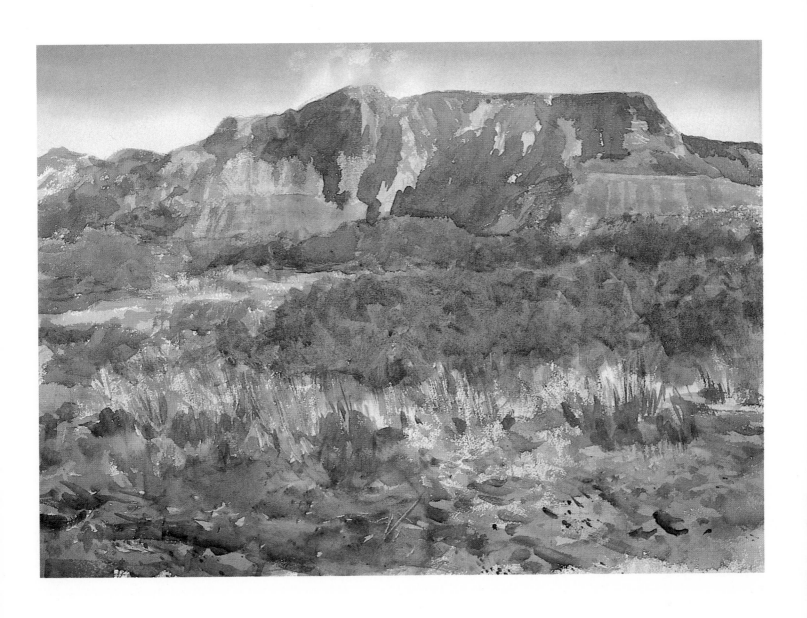

SEDONA SUNLIGHT
Watercolor on paper,
15 x 22 in. (38.1 x 55.9 cm)

I have conducted several painting workshops in Sedona, Arizona. The participants get real excited about the red mountains. However, I confess that I soon grow tired of their spectacular qualities and seek other subject matter of which there is an abundance close at hand (see *Morning, Oak Creek*, page 137). I tried to make the mountain the point of interest by rendering its light and shadow pattern sharp and clear. The middle distance and foreground were given softer and more fuzzy edges. I painted the sky first with a wash graded lighter toward the top of the mountain range. The cloud at the peak was lifted with a squeezed-out, damp sable brush. The orange and red tones were painted on the mountain and allowed to dry; then the cool shadow tones were superimposed. For these I used phthalo blue. The warm color of the underpainting, which show through, turns the blue to purple in some areas and green in others. This half sheet was painted throughout with one brush, a number 12 round sable.

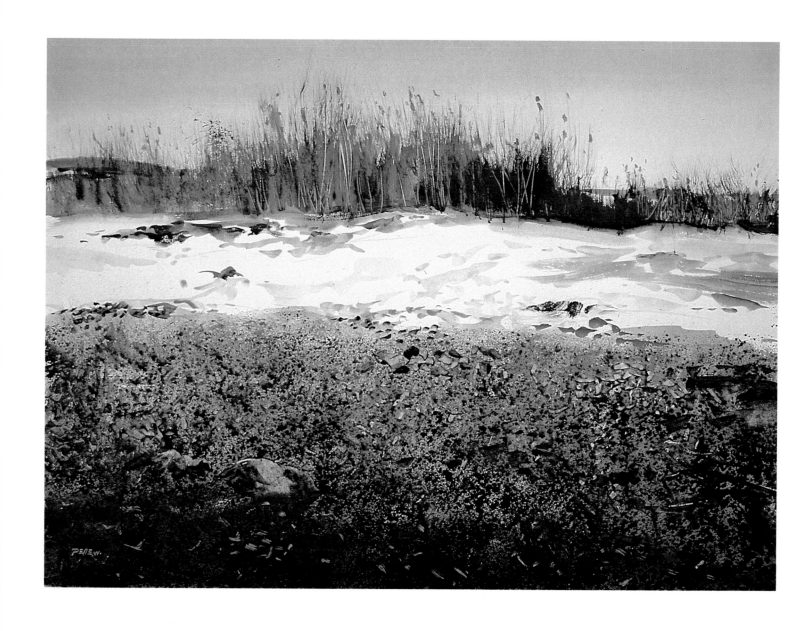

ISLAND WINTER
Watercolor on illustration board,
22 x 30 in. (55.9 x 76.20 cm)

I seldom paint from photographs but sometimes I find it necessary to do so, as it was with this subject. One of the Norwalk islands on Long Island Sound on a cold January day isn't exactly a comfortable place to set up and paint. But the islands are beautiful and I had been wanting to do something with them for years. So out came the old secret weapon and, click, click, I had something to work from in the comfort of the studio. Starting with the sky, I used a graded wash of phthalo blue. I painted the tall beach grasses and weeds with burnt and raw sienna and then with burnt umber for their darker parts. Next, I put in fingernail scratches for the lights. And finally, using an old, worn whisk broom dipped in fairly thick burnt umber and given an upward flip, I painted in the thin dark lines against the sky. The foreground is dark spatter over burnt sienna washes with fingernail work for the rocks and light-toned pebbles. The snow is mostly white paper with some warm and cool gray washes.

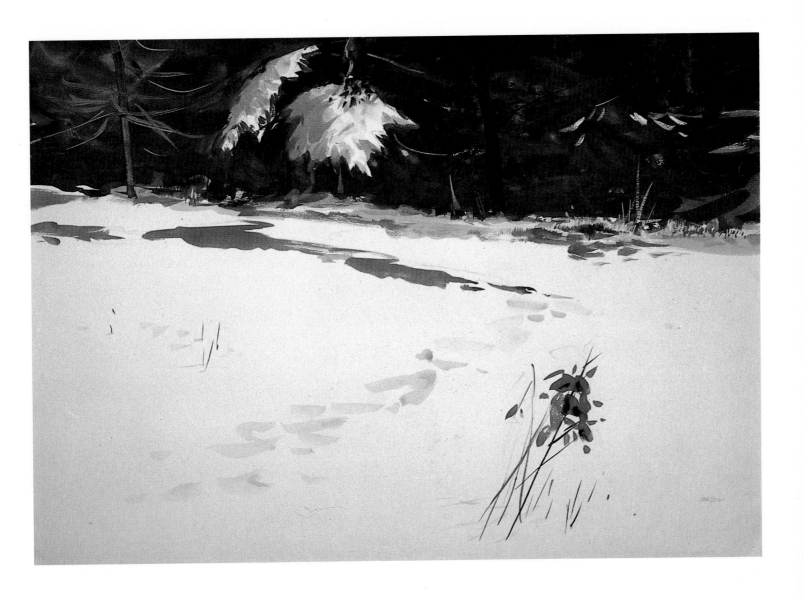

FRESH SNOW
Watercolor on illustration board,
15 x 22 in. (38.1 x 55.9 cm)

There had been a snowfall during the night, but the sun was out in the morning. I walked over to the grounds of the Nature Center to look around. Snow laying on the lower branches of a pine tree caught my eye and I stopped to study it. I had no sketching gear with me; so I let it soak in, then walked rapidly home to paint it from memory in the studio. The result was the very simple statement seen here. If I had painted on the spot, I might have been tempted to add unnecessary detail, and probably the painting would not have had the big, almost abstract pattern it now has. Except for the few lights on the dark background at the right, all the snow areas are white paper with a few shadow tones of phthalo blue. The dead tree on the left was scratched into the wet background with my fingernail. The dark background is a mixture of raw sienna and phthalo blue. The warm tones are raw sienna; burnt sienna with phthalo blue was added to tone down the area of bare ground through the center. Some cadmium red was used on the foreground weeds.

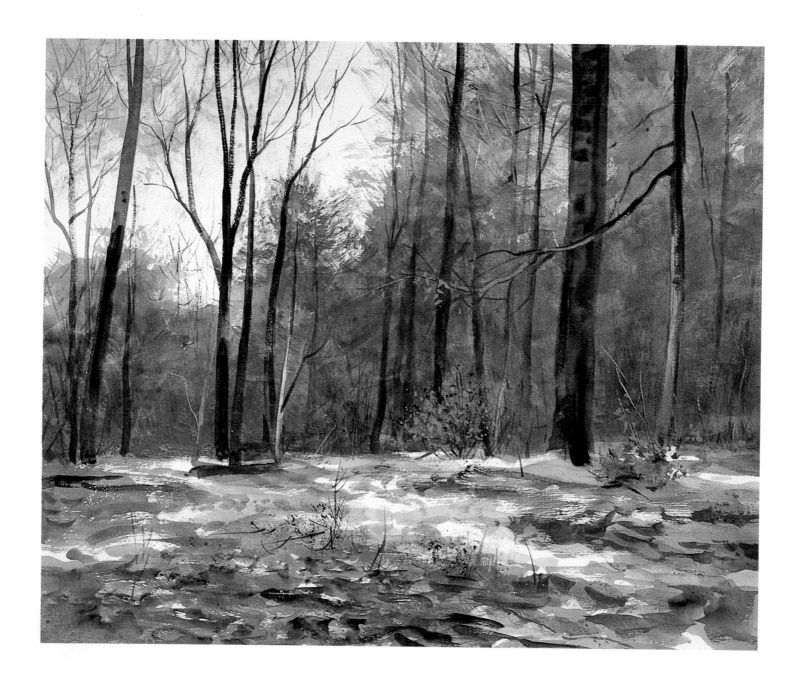

FIRST SNOW
Watercolor on illustration board,
16 x 20 in. (40.6 x 50.8 cm)

I never tire of the seasonal changes that happen in the woods behind the studio. From the tender greens of spring to the cold grays of midwinter, this little patch of wooded land has had a great appeal for me. This watercolor was painted one early November day after a light snowfall that lasted only a few hours on the ground. A bold and rapid attack was necessary: I completed this work in forty-five minutes. First the sky went in—yellow ochre with a touch of cadmium orange. Then the dark gray mass of the background trees—burnt umber, raw sienna, and phthalo blue. Next came the warm foreground of fallen leaves—burnt sienna with some dark accents of burnt umber. The snow is untouched white paper. The tall dark tree trunks were painted last. In woods paintings I establish the big pattern first, then put the tree trunks where they will do my composition the most good. Some lights were scratched out. For the light tree left of center I used opaque white.

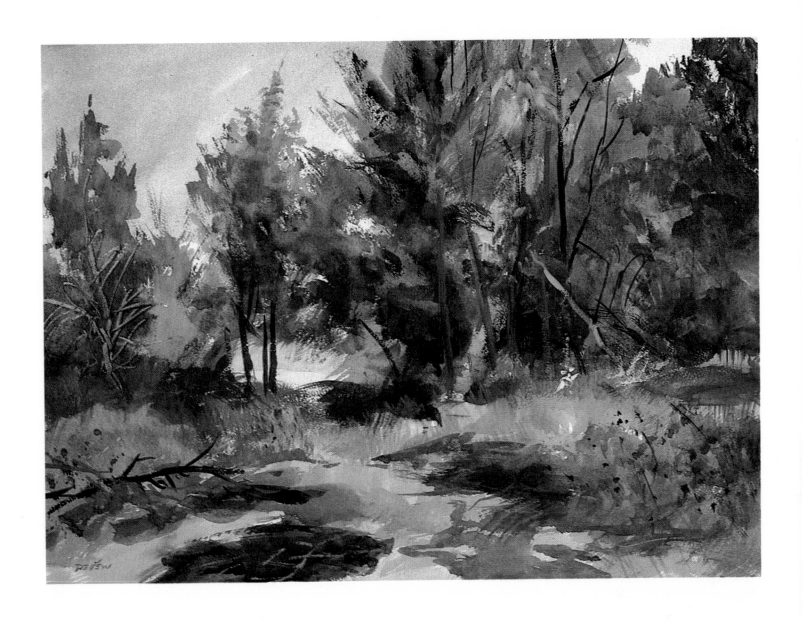

NATURE TRAIL
Watercolor on paper,
15 x 20 in. (38.1 x 50.8 cm)

This wooded area in Westport, Connecticut, has provided me with many subjects. It is known as the Nature Center. Trails have been cut through the woods, around the pond, and along the banks of Stonybrook. It's an ideal place to study the different types of trees, grasses, weeds, etc. I painted this on a sunny summer day. I often hear the complaint, "But everything is so green in summer." True, but it didn't keep John Constable from painting the English summer which is plenty green. I don't have any prepared greens on my palette. I mix them with combinations of blues and yellows. I painted with a one-inch flat sable. The tree trunks were put in last with a number 6 round sable. Some lights were scratched on the darker tones with the fingernail.

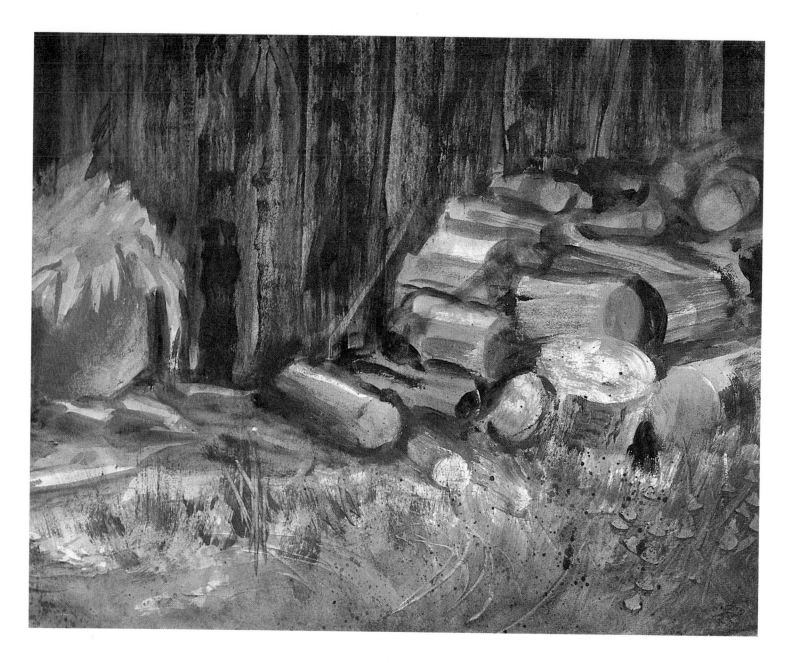

WOODSHED (above)
Watercolor on illustration board,
10 x 13 in. (25.4 x 33 cm)

When in Vermont with a painting group, I tried to tell them that the picturesque covered bridges and old weathered barns were not the only things worth painting there. I thought I could prove my point by painting this old pile of logs lying under a shed. I should have known better. Only one girl stayed to paint the logs. The old boards in shadow that form the background were painted with mixtures of burnt umber and phthalo blue. Their character was suggested by the downward stroke of a razor blade held flat against the paper while the wash was wet. The picture's remaining warm colors went in next. When these were dry, the cooler tones were washed over them. The warms are yellow ochre and burnt sienna; the cools, a mixture of burnt umber and phthalo blue. There are fingernail scratches and drybrush in the foreground, with some spatter on the right.

THE LITTLE CHAPEL (right)
Opaque watercolor on paper,
7½ x 11 in. (19.05 x 28 cm)

This chapel is on the grounds of the Hotel Hacienda Vista Hermosa in Mexico—a lovely name for a beautiful place. The ancient chapel was poorly lighted. What light there was came from a small window high up one wall. I scouted the place for several days to determine the time when the light would be best. I decided that the picture should be small and rapidly painted. I chose an eighth sheet, that is, one-eighth of the standard imperial 22-by-30-inch sheet of watercolor paper. The old masters of the medium often worked with this size. By using opaque, I avoided slow-drying wet washes. I used my regular watercolors but mixed them with opaque white to make a gouachelike paint.

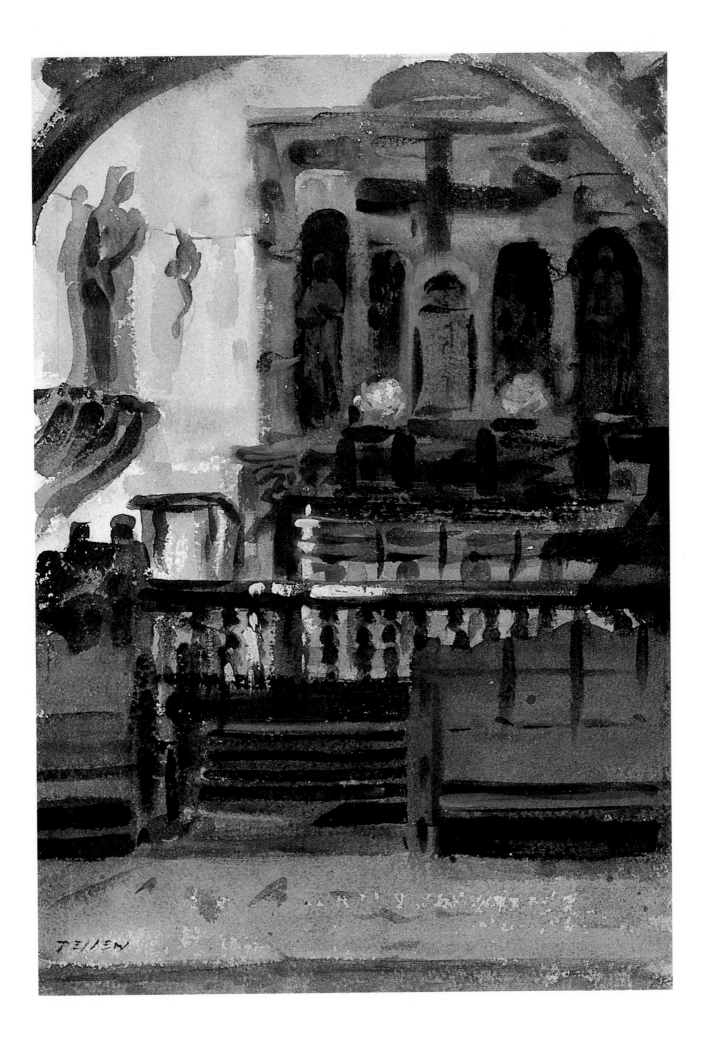

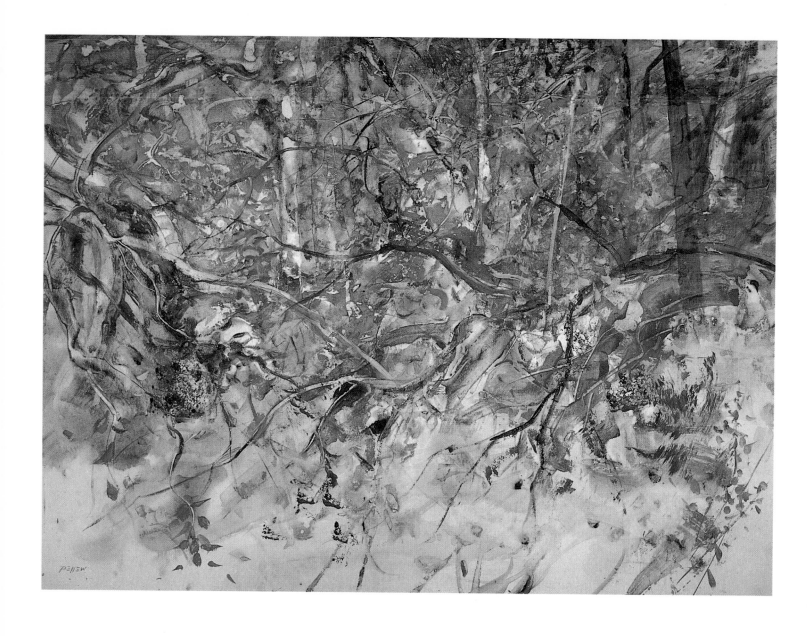

IMPROVISATION
Acrylic on illustration board,
22 x 30 in. (55.9 x 76.20 cm)

This painting is as close as I ever get to abstraction. Nature is still present. However, the goal is to create interesting color patterns in an all-over design that suggests a mood of nature and to get away from the dry, tight rendering school that never permits the viewer to use his imagination. I feel my painting suggests trees, a tangle of branches, and underbrush in a sunlit wood. This kind of painting I do as a change of pace after a long spell of on-location work. It's fun and it helps to loosen one up. I spread the colors into a film of clean water on the surface of the board using a palette knife and, at the same time, used a razor blade, sponge, and the knife to bring out lights. Many changes were made as the work proceeded. At one point there was a figure in the picture. She looked out of place and so had to go. Being in fast-drying acrylic, the painting had to be done at white heat. I worked with many tools that I never use on my more traditional watercolors: torn rags, paper towels, a palette knife, sponges, razor blades, an old well-worn house painter's brush, and, of course, my fingernails. Yes indeed, as I look at this, I feel I have come a long way from the God-bless-every-blade-of-grass school.

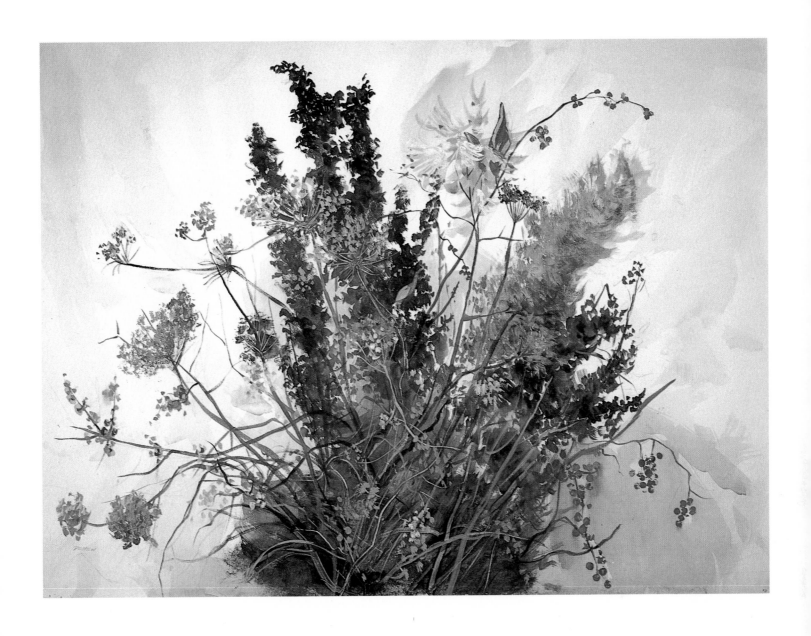

WINTER BOUQUET
Watercolor on illustration board,
22 x 30 in. (55.9 x 76.20 cm)
Collection Mrs. Elsie Pellew.

Now and then, maybe twice a year, I paint flowers. This one is a dried arrangement of weeds, pods, grasses, etc., that Elsie gathers in the fall. The paint is fairly opaque on an almost white background. The usual thing is to show the flowers or, as in this case, weeds in a container of some sort. Often the container is as intersting as what it contains. I eliminated it here, letting the dried arrangement speak for itself. The rich color and variety of shapes were all I needed. After lightly sketching the subject in pencil, I put a few pale gray washes on the background, avoiding any textures or definite tones that would compete with the bouquet. Picking up watercolor paint as thick as it comes from the tube, I started with the dark red sumac. The warm color halftones in the bouquet's lower part were next to go in. When this was dry, the lighter touches using color mixed with opaque white, were painted over the undertone. For the thin dark stems I used a rigger; for the light ones, my fingernail.

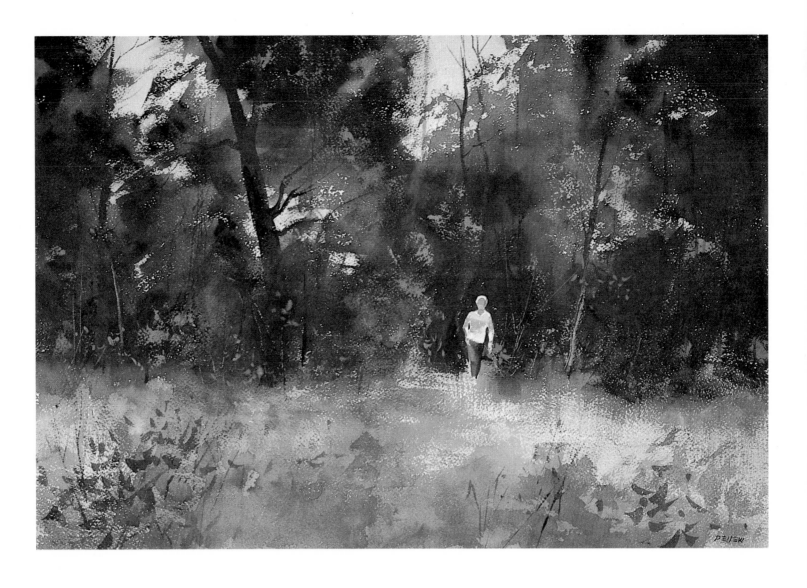

AUTUMN
Watercolor on rough paper,
18 x 26 in. (45.72 x 66 cm)

I painted this watercolor in the studio from a sketch made at the Nature Center. It is a study in big, simple masses. Imagine the thousands of leaves that would be seen if one were to look at so many trees. Notice how few leaves are actually shown in the painting. I believe that the student should learn to work simply before going on to a more detailed type of realism. First, the big abstract pattern—a few big shapes are better than a lot of little ones. I first painted the sky using yellow ochre and cadmium orange, then the big foliage mass using a mixture of burnt sienna and burnt umber, and next the darker foliage tones using a mixture of burnt umber and phthalo blue. I cut around the figure, leaving it white paper. Next yellow ochre and both siennas were used for the foreground. Note in the light area the drybrush suggesting foreground grasses. The dark tree trunks were painted with a thick mix of burnt umber and phthalo blue. Some darks left on the palette were used for the weeds left and right. In the final step I worked to give the figure color and form.

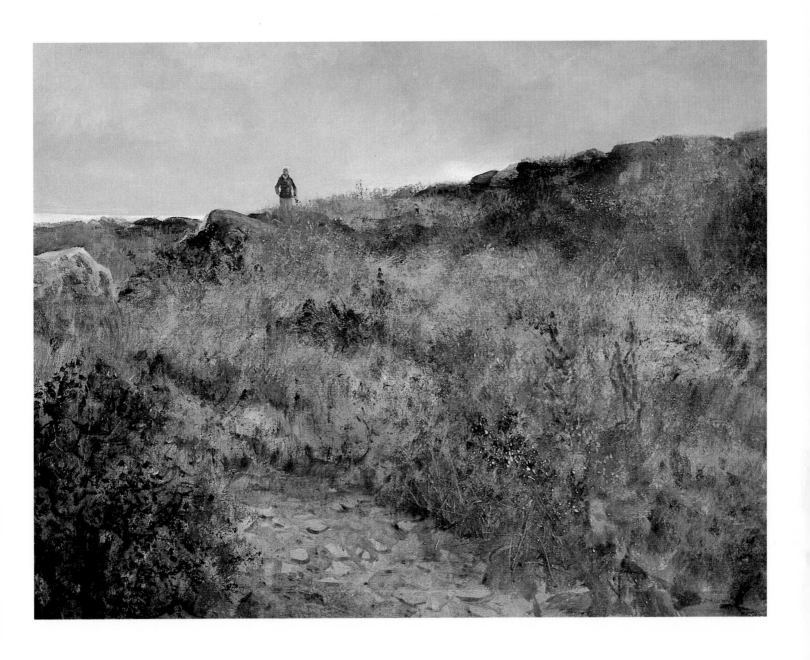

ABOVE THE CLIFF

Acrylic on canvas,
30 x 40 in. (76.20 x 101.6 cm)

A watercolor sketch and some photographs brought back from Cornwall were the inspiration for this painting. One breezy September morning I introduced my painting group to Zennor headland. Most of them enjoyed looking down at the surf breaking in the cove far below, but one lady refused to walk the last few hundred yards to the spot where I made the sketch for this painting. The three-hundred-foot drop from the cliff's edge to the rocks below was too frightening.

All the land painting in this area was scrubbed in with a two-inch house painter's brush. I used yellow ochre, raw and burnt siennas, and burnt umber. I used cadmium yellow only for the foreground spatter suggesting wild flowers. The bracken-covered headlands are fascinating to paint. I felt it was best to suggest the detail rather than attempt a monotonous copy of it. I painted out a seated figure that was just below the present standing one. I needed to break the line dividing land and sky. In the sky I used mixtures of titanium white, cerulean blue, and burnt umber. Elsie posed for the figure again.

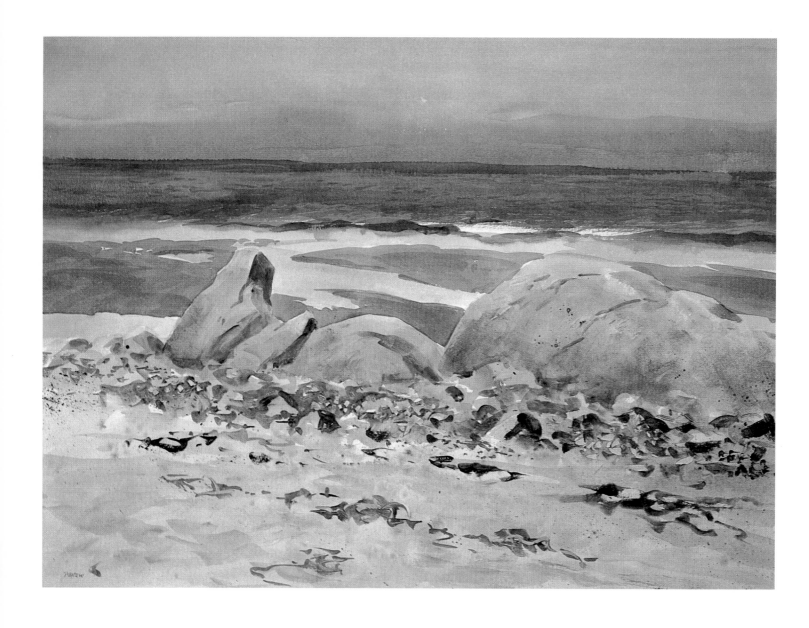

THE SILENT SHORE
Watercolor on illustration board,
22 x 30 in. (55.9 x 76.20 cm)

The warm, hazy light and the fog bank offshore attracted me to this subject. I had often painted on Wingaersheek beach near Gloucester, but always in the morning. This was my first experience of it in afternoon light. These same rocks can be seen in *A Cape Ann Beach*, reproduced in my book *Painting in Watercolor*. Of course, the lighting is different, as is the composition.

The beautiful late September day, my daughter Elma painting a short distance from me, and friends from the Painting Holidays group just over the sand dune—all made it a happy afternoon. The watercolor I painted that day was a half sheet. This full sheet was painted from it in the studio. The sky is a wash of phthalo blue; the fog bank a mixture of cadmium red and phthalo blue. I used the same mixture for the dark sand behind the rocks. The ocean is phthalo blue overwashed when dry, with a green made with raw sienna and phthalo blue. In the rocks I used yellow ochre, cadmium orange, burnt sienna, burnt umber, and phthalo blue. I started with the lightest tones and finished with the darks. The colors used in the rocks were diluted with clean water and then used in the foreground beach.

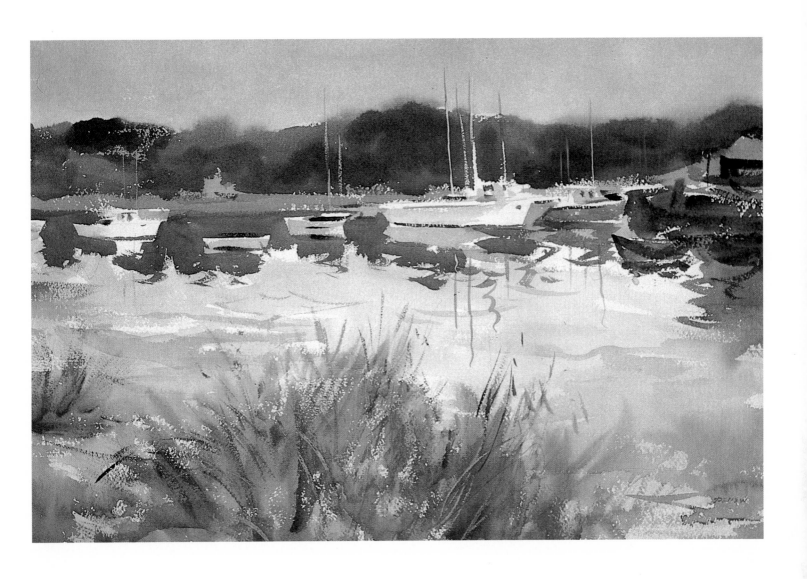

FIVE MILE RIVER
Watercolor on RWS rough paper,
15 x 22 in. (38.1 x 55.9 cm)
Collection Mr. and Mrs. George Gilbert.

The Five Mile River flows into the Long Island Sound. At this point the Darien Marina, with its anchored yachts and pleasure boats coming and going, presents the artist with a lot of good painting. In this traditional transparent watercolor I tried to create the mood of a sunny September morning. The trees retain their summer greens, but the salt-marsh grass in the foreground begins to show a little fall color. This was boldly painted with much of the drawing done with the brush.

I started with the sky, and while it was still damp, I put in the first wash of the trees. I wasn't concerned with the masts of the boats at this point because I had planned to add them with opaque anyway. All my greens are mixtures of raw sienna and phthalo blue. I painted the trees' reflections around the boats leaving the paper white. In the sky and water I used yellow ochre and phthalo blue. The foreground grass was painted with yellow ochre, burnt sienna, raw sienna, and phthalo blue. Of this one I think I can truly say that the images that stay with us longest are the ones that are not fully explained.

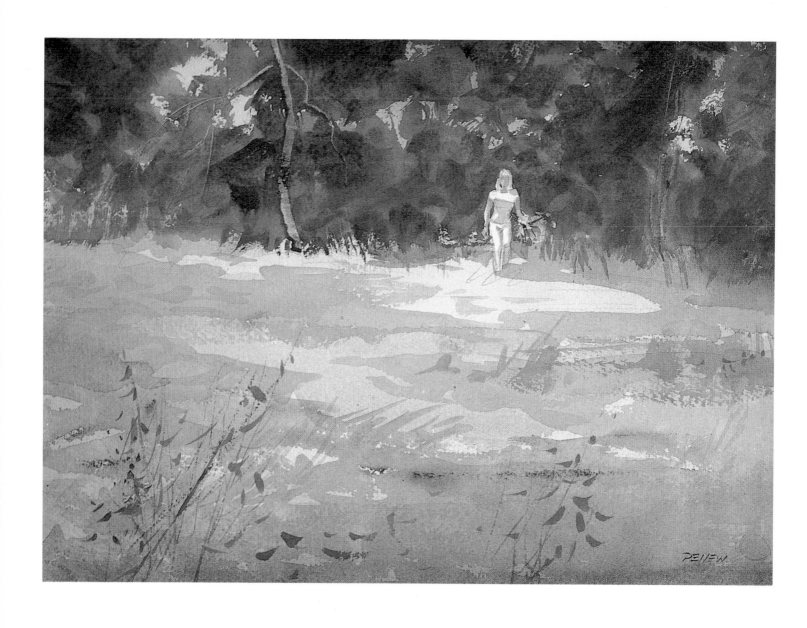

SEPTEMBER SUN
Watercolor on paper,
10 x 14 in. (25.4 x 35.6 cm)

I have often painted this subject, each time trying to achieve greater simplicity.
In this version I think I hit the jackpot. Why so much concern with simplicity?
Well, I think watercolor is at its best when used to make a simple statement or
even an understatement. I tell students to suggest the detail when working from
nature, but not to try to copy it. Only three colors were used here: burnt sienna,
yellow ochre, and phthalo blue. I painted around the little figure, leaving it
white paper. The tree trunk, with its light branches, I scratched into the damp
paper with my fingernail. The color washes that give the figure form were put in
last. Note that the dividing line between trees and meadow is well above center.

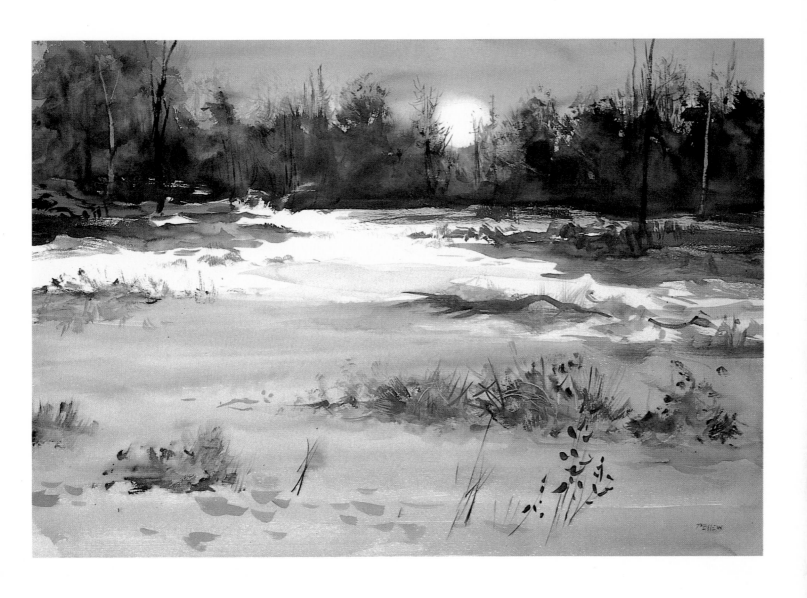

DECEMBER AFTERNOON
Watercolor on illustration board,
15 x 22 in. (38.1 x 55.9 cm)
Collection Mr. and Mrs. Edward Robinson.

The best advice I can give anyone attempting to paint snow scenes is to make use of the white paper as much as possible. Of course, there will be tonal varieties within the snow areas, but its lightest parts can be pure white paper as in this memory painting, which I did in the studio. Scenes like this I often see when driving on my state's highways in midwinter. I store up the memory; then when I paint the resulting picture, it is not the memory of a particular place but of several similar places. I was trying here for a late afternoon mood with a pale almost-sun sinking beyond the trees. The colors are raw sienna, yellow ochre, cadmium red light, burnt sienna, burnt umber, and phthalo blue. The darkest darks are a mixture of the last two. A couple of light tree trunks were fingernail-scratched into the dark mass before it had dried. The snow's gray tones are mixtures of phthalo blue and a little cadmium red light.

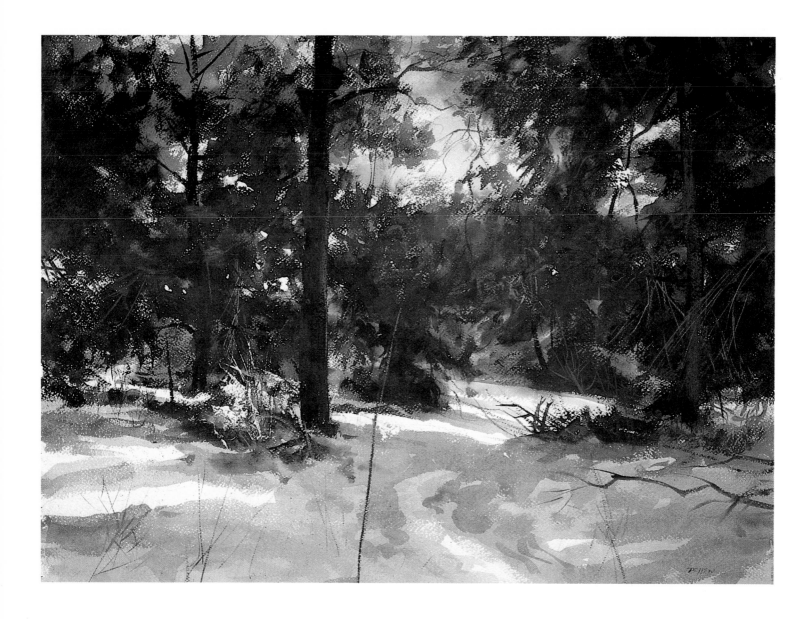

FARINGTON'S PINES *(above)*
Watercolor on rough paper,
22 x 30 in. (55.9 x 76.20 cm)

Walking in the woods one morning after a snowfall, I looked across to my neighbor's yard and this is what I saw. The temperature was fairly high for January, about 45°, which allowed me to stay long enough to do a quarter sheet on the spot. I then used it to paint this larger sheet in the studio. The rough paper was right for creating the textures I wanted. As in almost everything I paint, I kept my palette simple. The dark foliage is a mixture of burnt sienna and phthalo blue, with burnt umber added for the tree trunks and branches. The shadow patterns on the foreground snow were first underpainted with a pale pink wash of cadmium red light, allowed to dry, then overpainted with a cool wash of phthalo blue with a bit of burnt umber in it. Looking over what I have written so far, I find I often mention the use of phthalo blue— a color so many painters are afraid of. Don't be. Sure it's strong, but it's also beautiful. Learn to use it.

ROCKY CLIFF *(right)*
Watercolor on illustration board,
15 x 22 in. (38.1 x 55.9 cm)

Going painting with my daughter Elma one late summer morning, we discovered this interesting rock formation on the road to Silvermine. The cloud shadows passing over the rock face were a challenge, as was the variety of summer greens. I seldom paint vertical compositions and tell students that, because they may be painting a tall object, it isn't always necessary to use a vertical. I like to use Hopper's famous lighthouse painting as an example. So, I used a vertical. This is a transparent watercolor painted on location in forty minutes. Painters should never work from nature longer than an hour. The sun doesn't stand still and the changing light makes it difficult to hold the first impression. Landscape students should learn to paint fast, which is almost impossible to teach the amateur. Except for the trunks and branches on the hilltop, I painted this work with a one-inch flat and a number 10 round sable.

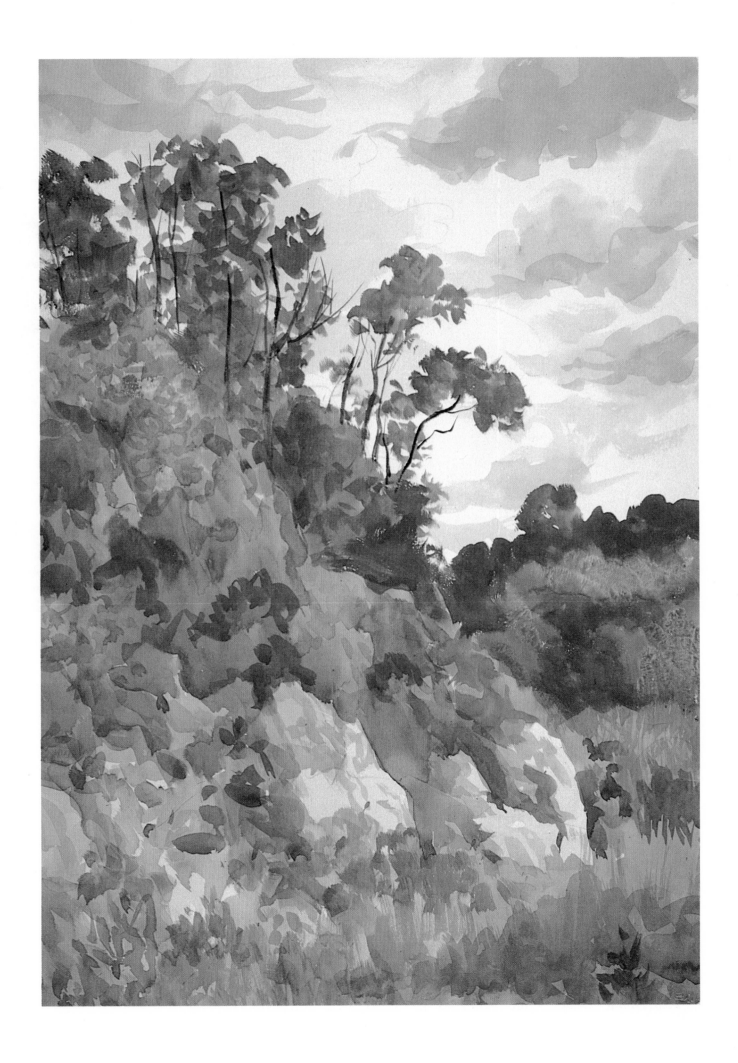

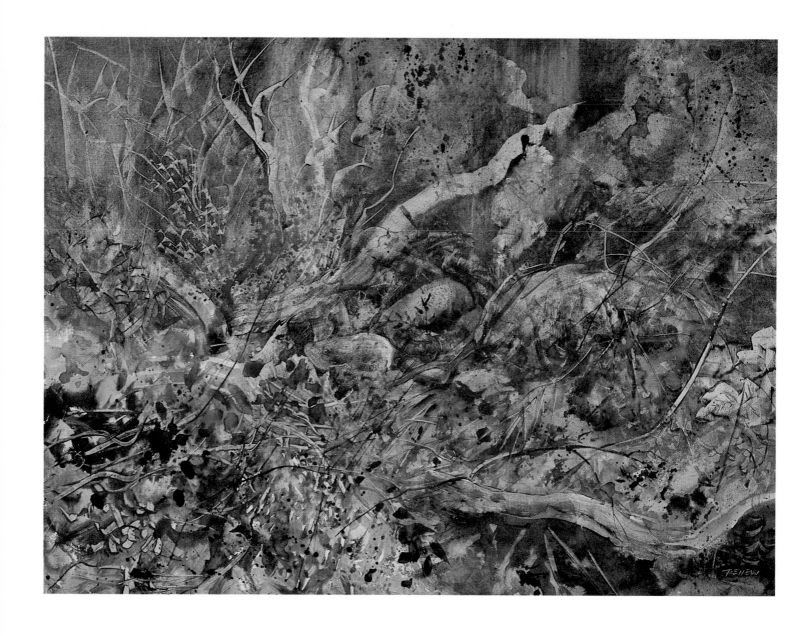

A PLACE OF MYSTERY
Watercolor on illustration board,
22 x 30 in. (55.9 x 76.20 cm)

This picture started out as a very detailed close-up of nature painted on location in the woods. After studying it for a month I grew tired of it. What was the sense of painting all that detail when a camera could do it just as well—or better? Placing the board on the grass outside the studio, I used the garden hose to wash it off. The results pleased me. What was left were shapes and stains that suggested all manner of mysterious things. Putting the board flat on the studio table, I started adding darks and lifting out lights. I put in the darks with a one-inch flat sable; the scraping was done with a razor blade and the side of the palette knife. Parts of the dark background near the top were blotted and lifted with a damp paper towel. No opaque white was used—all the lights and halftones were either scraped or lifted out. The final result is a more creative effort than my original photographic rendering. The images that stay with us longest are the ones that are not fully explained.

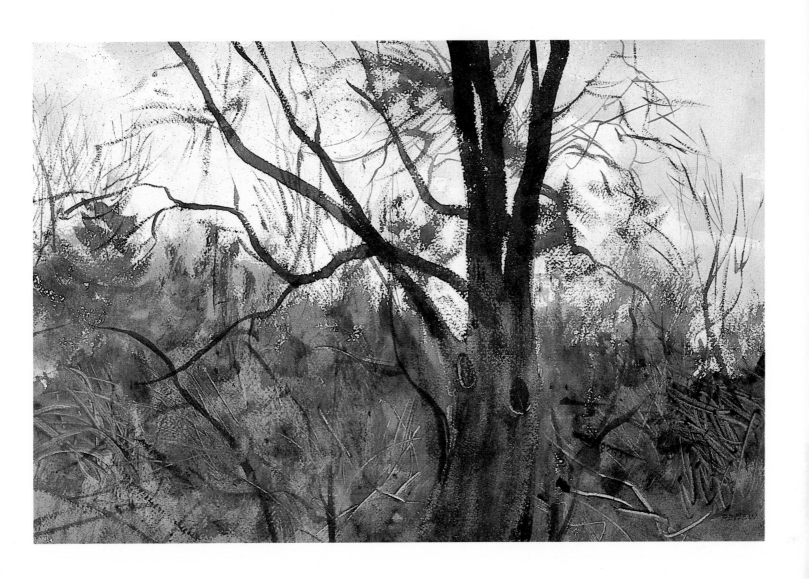

NOVEMBER TREES
Watercolor on rough paper,
14 x 23 in. (35.6 x 58 cm)

I painted this watercolor—a half-hour sketch—as an outdoor demonstration for my students at the Silvermine Guild of Artists in Connecticut. I used only three colors—burnt sienna, burnt umber, and phthalo blue. I painted directly with the brush, without preliminary pencil work. The sky color is a mixture of burnt sienna and phthalo blue with plenty of water which was rapidly painted in with a one-inch flat sable. I left some of the white paper uncovered. The trees and bushes of the picture's lower half went in next in mixtures of all three colors. The light streaks are fingernail scratches on the damp, not wet, paper. Note dry-brush was used to suggest twig masses against the sky. The foreground tree was painted with a thick mixture of burnt umber and phthalo blue, and the same combination was used for the thinner branches and twigs.

THE LITTLE STREET, NAZARE (left)

Watercolor on paper,
15 x 22 in. (38.1 x 55.9 cm)

European street scenes can make very picture-post-card-type paintings if the painter isn't careful. To create something more artistic, I think, one must avoid photographic detail and paint broadly. I know most of the street scenes we see exhibited are painted from color slides taken on European vacations. I have been guilty of doing just that, but not here. This was painted while I was sitting on a box with two cute little Portuguese children in attendance. Notice that there is detail in the rendering. Any appearance of reality is due to observation of proportions, perspective, and, most of all, the relationship of tonal values. When the tonal values are correctly related, a simple statement will have the illusion of reality. The brushes used here were round sables, numbers 8, 10, and 12. There is no fear of getting fussy with details with that combination. All the warm tones were painted first and allowed to dry. The cool shadow tones were then painted as a transparent wash over the warm underpainting.

FISHERMAN'S CHAPEL, ERICEIRA (above)

Watercolor on paper,
9 x 5¼ in. (22.9 x 13.34 cm)

This painting resembles those watercolors the nineteenth-century English artists brought back from their travels in the East. At least I hope it does—those boys were darn good. It was painted one sunny afternoon in Portugal. The gleaming white building against the cloudless blue sky and the dark ocean was pure classic watercolor. Some old-time painter once defined a watercolor as "a light picture with dark spots." This, perhaps, is what he had in mind. I first painted the sky with a pink tone going carefully around the building. When this was quite dry, I superimposed a wash of phthalo blue over it. At the horizon I added a slightly darker mixture of blue and red which I also put into the wet sky; and by turning the board around, I allowed it to blend softly with the sky wash which was still wet. The building's sunlit dome, front and sides received a pale wash of yellow ochre. Over this, when dry, I painted in the shadow tones with a mixture of cadmium red light and phthalo blue. I put a few opaque white highlights on the building. Except for these, the treatment is transparent throughout. Note how dry-brush in the left foreground adds a little variety or contrast to a rather simple rendering.

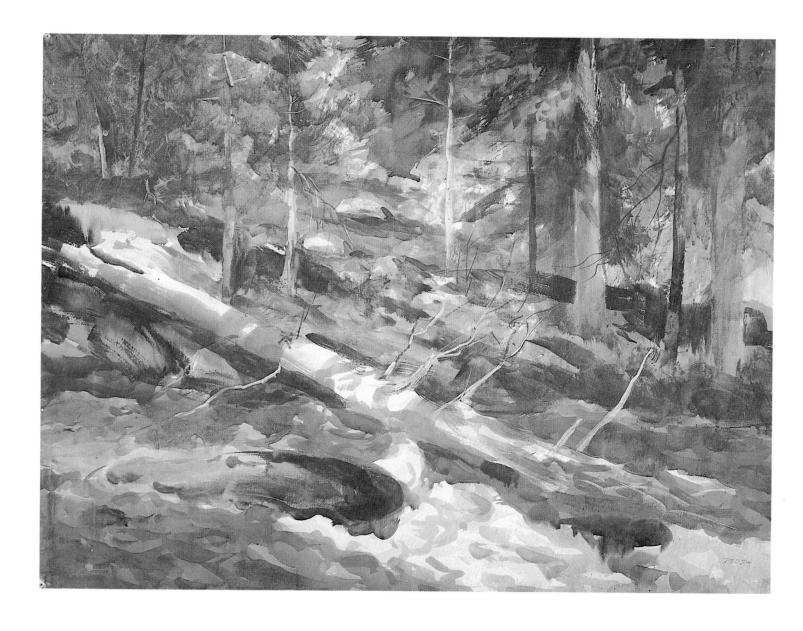

FOREST INTERIOR
Watercolor on illustration board,
22 x 30 in. (55.9 x 76.20 cm)

When this work was shown at a meeting of the Fairfield Watercolor Group, a member called it a Sargent, which I considered a compliment. I have always admired that master of the watercolor medium. It is a close-up of an area of the Kit Carson National Forest in New Mexico. It's a straight transparent treatment in which I tried to capture the splatter of flickering sunlight filtering through the trees. The dead fallen tree acts as the main point of interest—its lightest lights are uncovered white paper. Its branches are fingernail scratches in the wet washes, as are the two light tree trunks in the background. I painted around the larger trunks at the right, coloring them later. I used most of the colors on my palette for this watercolor—cadmium yellow, cadmium orange, burnt umber, burnt sienna, raw sienna, and my two blues, cerulean and phthalo. I worked from light to dark, with the darkest darks going in last, and painted with a one inch-flat and a number 12 round sable.

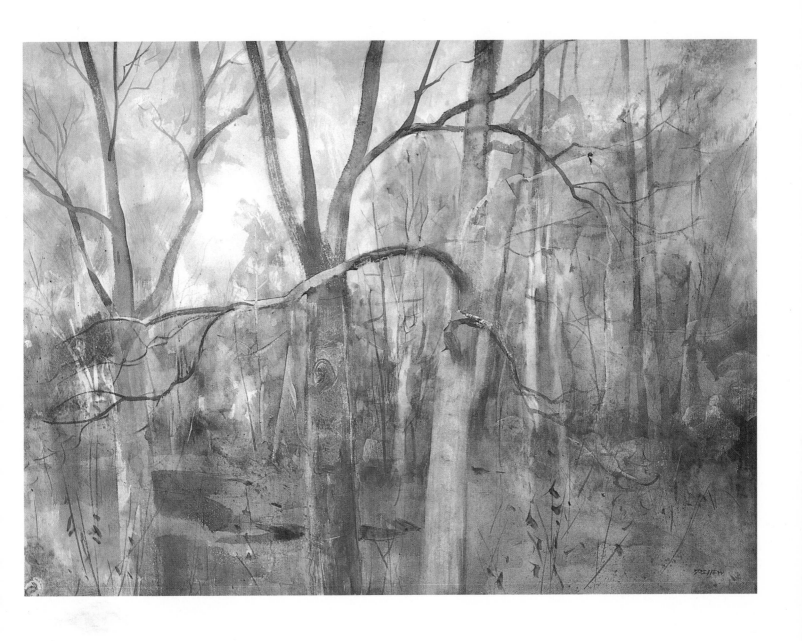

A PLACE OF MAGIC
Watercolor on illustration board,
22 x 30 in. (55.9 x 76.20 cm)

An earlier version of this memory painting of moonlit woods is reproduced in my book *Painting in Watercolor,* published in 1970. I called it *The Rising Moon.* My method is to study the subject at night and then paint it next morning in the studio. This is what Whistler did when he painted his beautiful Thames nocturnes. This picture has taken two awards, one at the New England Annual and another at The American Watercolor Society. It's difficult to describe my procedure for this painting. I first painted a variety of quite dark tones over all, but left the moon white. When these tones had dried, I sponged them with clean water, leaving a pattern of light to dark grays. When the surface was damp, not wet, I scraped over the lighter tree trunks with a razor blade. The darker trunks and branches were then indicated. A final wash around the moon gave a sharp edge and a few last tissue blottings in the damp background finished the painting. The colors used are burnt umber, ivory black, and phthalo blue.

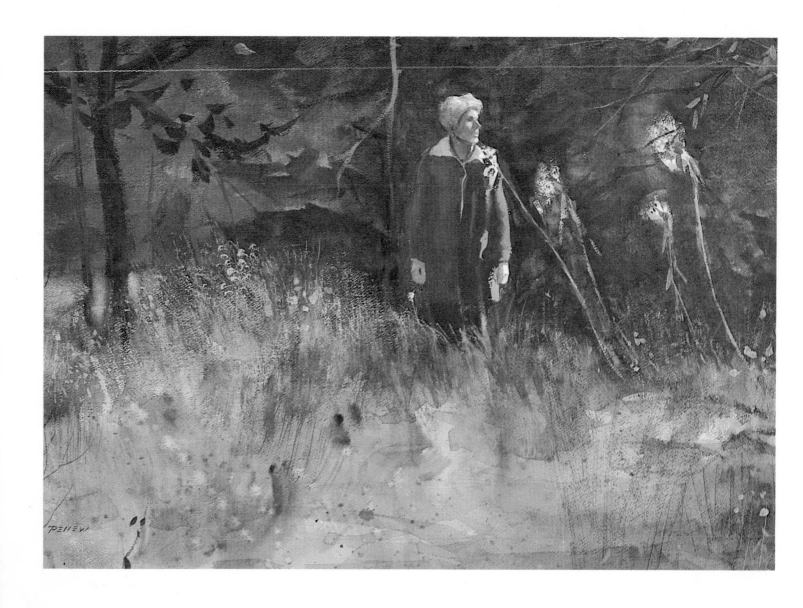

OLD FIELD WALK
Watercolor on cold-pressed paper,
12 x 22 in. (30.5 x 55.9 cm)

In New England the trees that grow up where there was once cleared land are called old field woods. This second growth can be very beautiful. There's a lot of it around our home and we use it for walks and nature study. It was the milk-weed pods in the afternoon light against the dark pines that caught my attention and suggested the subject for this picture. When the model posed in the same light, I was sure I had something too good to miss. A pencil drawing of the figure was all I did on the spot. I carried one of the pods home and tacked it to the wall. The rest was a studio painting from memory. I used some opaque white in the pods, for the strong top light on the model's head, and also in the grasses left of center. The lighter parts of the dark background were scrubbed out with a damp bristle brush and blotted with a paper towel. The figure is larger than my usual figure in landscape. This one required more clearly defined features. However, I thought the dramatic lighting demanded this treatment. I painted it with a lim-ited palette—yellow ochre, raw sienna, burnt sienna, burnt umber, and phthalo blue.

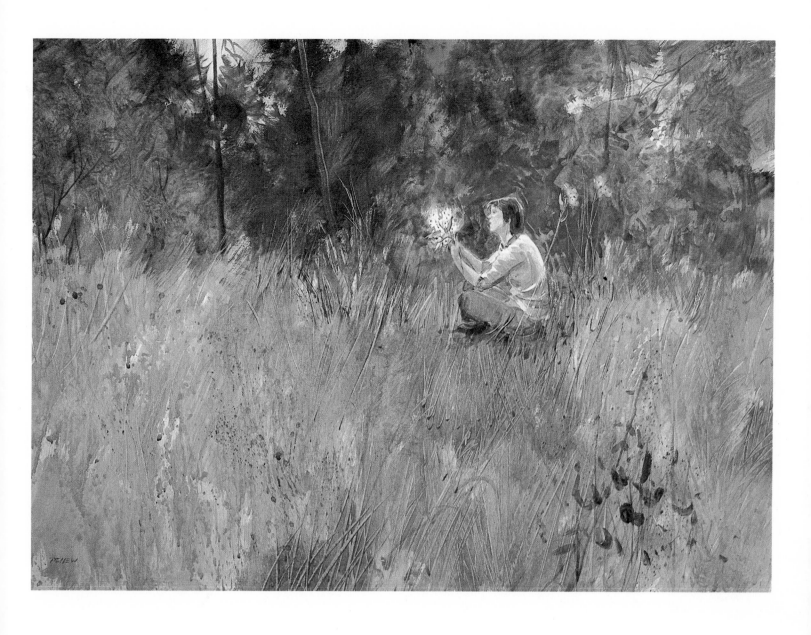

MILKWEED

Watercolor on paper,
27 x 35 in. (68.6 x 88.90 cm)

The people in my pictures are seldom painted from the model. I often press my students into service. I make pencil drawings or take photographs of them. Groups and small figures I do from memory. This girl was in one of my Colorado workshops. She didn't know she would fetch up in a Connecticut field picking milkweed pods. This is one of my larger watercolors. It was painted on Arches paper, the kind that comes in a roll. Except for the work on the figure, this is a big-brush painting. I used a three-inch house painter's brush for most of the work. Since the brush was old and not in very good condition, it was great held sideways for scrubbing in the trees and, with its bristles spread, did a good job on the tall grass. There are those who say a watercolor *must* be painted with expensive sable brushes. Then there are those, like me, who say baloney. This being a fall landscape, warm colors predominate. They are complemented by the cool cerulean blue of the girl's jeans. There are spatter and fingernail scratches in the foreground. The colors used in the grassy area are cadmium yellow light, cadmium orange, and burnt sienna. The background trees are a mixture of burnt sienna and phthalo blue.

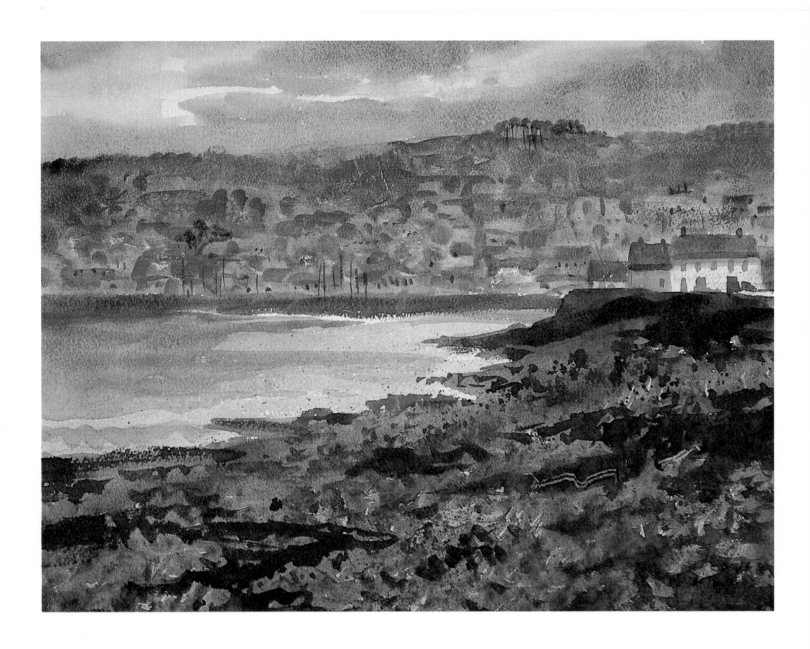

NEWLYN
Watercolor on paper,
11 x 14 in. (27.94 x 35.6 cm)

When artists discovered Newlyn in 1881, the cottages were strung along the cliff-top above the harbor. Today houses climb the hill to the very top. On the skyline in my painting can be seen the trees that Stanhope Forbes, R.A., planted around the house he built on the top of the hill. Elsie and I had tea in that house with his widow. How I wished it could have happened when the artist was alive. He was my boyhood hero. I'm sorry I never met him. Since those early days there have always been artists in Newlyn. It's not as well known now as it was when important paintings were sent to London for the Royal Academy exhibition. Some of England's best-known artists were trained here—Dame Laura Knight, Harold Knight, Sir Alfred Munnings, Dod and Ernest Proctor, and the American, Harry Leight Ross, who was also a Forbes student. Another American, the marine artist Gordon Grant, painted in Mousehole, a short distance along the coast from Newlyn.

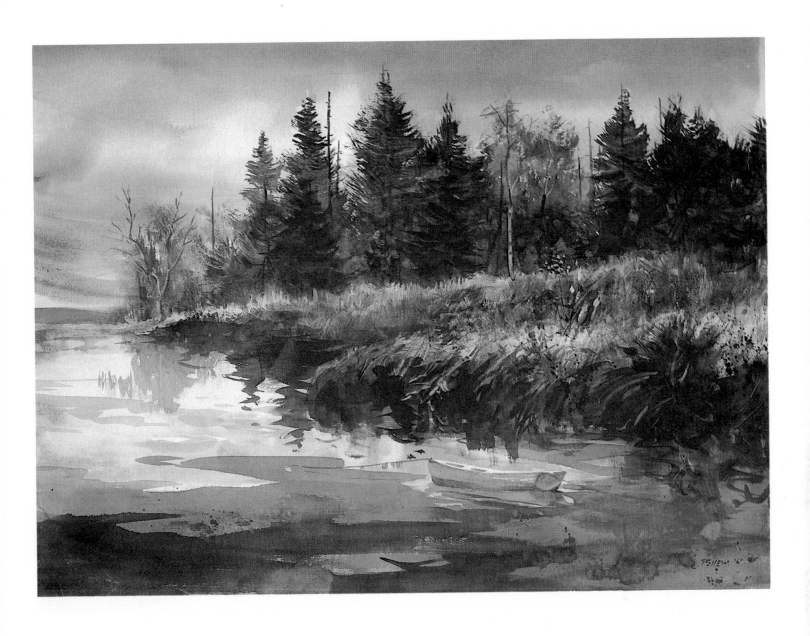

SALT MARSH
Watercolor on illustration board,
22 x 30 in. (55.9 x 76.20 cm)

I never tire of painting the salt marshes along the New England coast. They are paintable at any season but are especially so in the fall. It is then that the marsh grass called salt hay turns from summer green to shades of golden ochre and a color between pink and burnt sienna. The contrast of these colors with the dark green pines and firs is something to see—and paint. Students and amateurs have a lot of trouble with dark values when working in watercolor. That's because they start with too much water and not enough paint on the brush. When what should be dark dries out too light, they try to correct it by overworking. The result is a dead, muddy dark. I avoid this overworking by having plenty of paint on the brush with which to establish the value right at the start. In this painting the deep darks are not muddy because there was little overworking. For them I used mixtures of raw sienna, burnt sienna, and phthalo blue. Other colors used are yellow ochre, burnt umber, and cadmium orange.

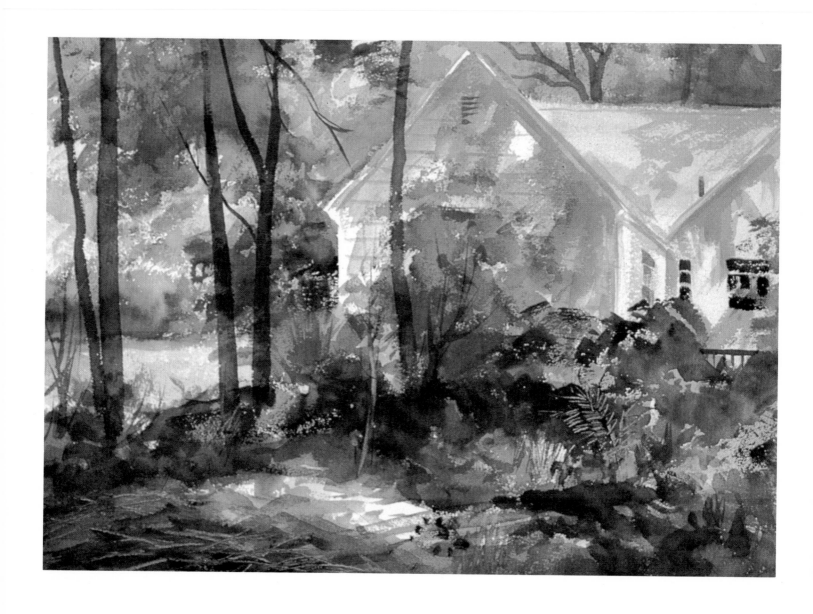

SUN IN THE MORNING

Watercolor on cold-pressed paper,
15 x 22 in. (38.1 x 55.9 cm)

I walked into the woods one June morning expecting to do a woods interior. On turning around, I saw the back of our house in sunlight with the trees casting shadows over it. Here was a challenge that had to be met. I sketched the house in with pencil. The rest was drawn with the brush as I worked. The light parts of the house are untouched white paper. The roof, however, is a light wash of yellow ochre with a touch of cadmium red light in it. The cast shadows are phthalo blue with a little of the red mixed in to take the sting out of the blue. The greens are all mixtures of raw sienna, burnt sienna, yellow ochre, cadmium orange, and cadmium yellow with phthalo blue. The dark tree trunks are a mixture of burnt sienna and phthalo blue. Notice that, although I could see thousands of individual leaves and blades of grass, I treated all the foliage simply. The whole picture was painted with one brush—a number 9 round sable, which is not a brush one would use for picky-picky detail.

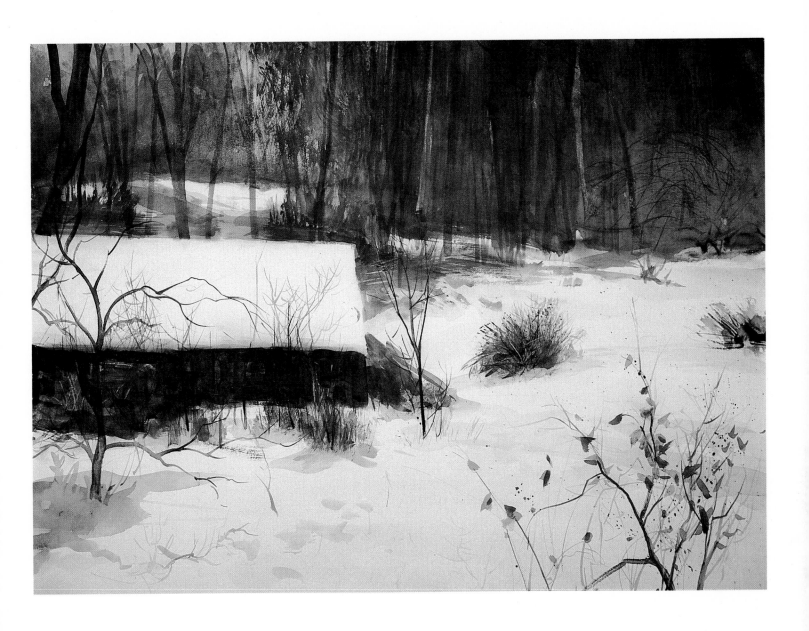

THE OLD SPRING HOUSE
Watercolor on illustration board,
22 x 30 in. (55.9 x 76.20 cm)

A quick on-the-spot pencil sketch on a cold day, plus a good memory, produced this watercolor in the studio. The subject is directly across the road from my home, on the property of the old Jonathan Adams 1785 farmhouse; so checking up was easy. If this painting had been made a hundred years ago, there would be no trees in the background, just cultivated farmland. I used a very limited palette for this—only burnt umber, burnt sienna, and phthalo blue. The darker darks are a thick mix of the umber and blue. The snow areas are white paper with a few pale gray washes here and there. When I first did the background trees, I'm afraid I overdid them. They competed with the building, which should have been the point of interest. I sponged out the whole tree area and repainted it more simply. For the twigs and branches around the little building and in the lower right foreground, I used a rigger; and for the rest, a one-inch sable.

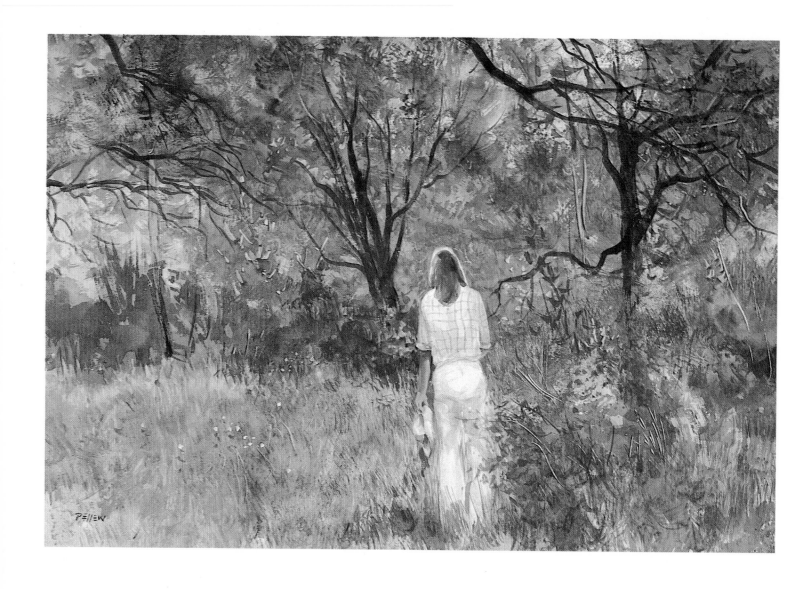

THE SOUND OF BIRDS
Watercolor on illustration board,
15 x 22 in. (38.1 x 55.9 cm)

I'm afraid I got carried away with the detail here. Not that I have anything against realism, but realism that doesn't stir the imagination is a dead thing and a bore. I used nature for the landscape and a photograph of my daughter Elma for the figure. This picture went through many changes and corrections that would have been impossible to make on the rougher surface of regular watercolor paper. Originally, there was a large, dark tree trunk in the foreground just to the right of the figure. Branches cut across the girl's back and legs. I painted that, but hated it. I decided to operate. Using clean water, a sponge, paper towels, and a bristle brush, I scrubbed and blotted out the offending trunk and branches. A little foliage and figure repainting and the picture was saved. The operation was so successful I now use this type of illustration board almost exclusively.

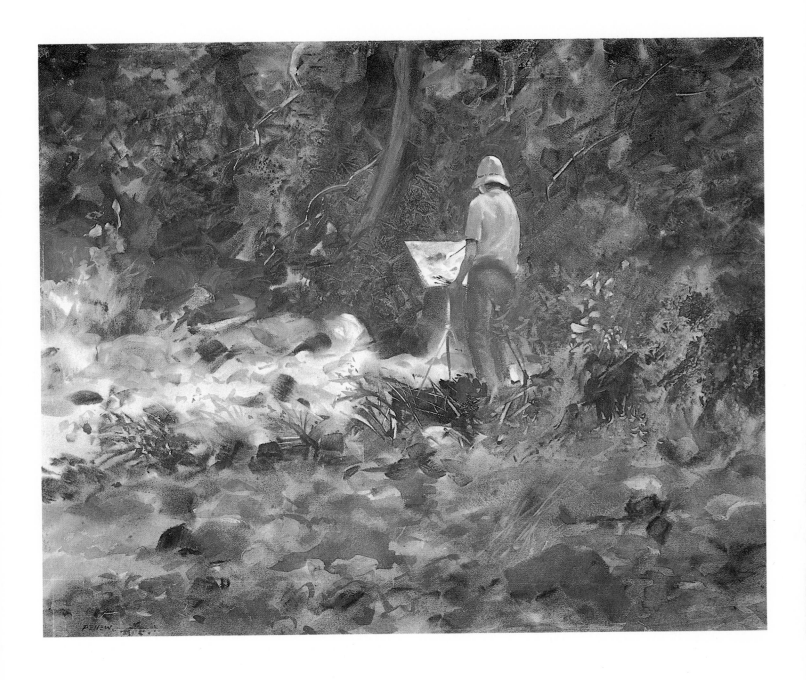

BETH PAINTING
Watercolor on paper,
24 x 30 in. (60.96 x 76.20 cm)

This beautiful subject was too good to miss. However, at the time I was busy with a class in Oak Creek Canyon, Arizona; so I captured it with the camera instead of the brush. There are painters who pretend to scorn the camera. There are some also who pretend they never use it when it's obvious they do. I think it's a useful tool but not one to be used as a crutch. Before its invention, painters made use of the camera obscura. Later, many leading artists—too numerous to name—used photographs. I like the composition of this picture. I think the figure is well placed. The bright paper the model is working on attracts the eye, making her the point of interest. The light on the ground directs the eye to the figure and the tree trunk in the background takes us up and out. A few scratches just below the easel and some opaque touches on the model's shirt and on the sunlit bush behind her, completed the painting.

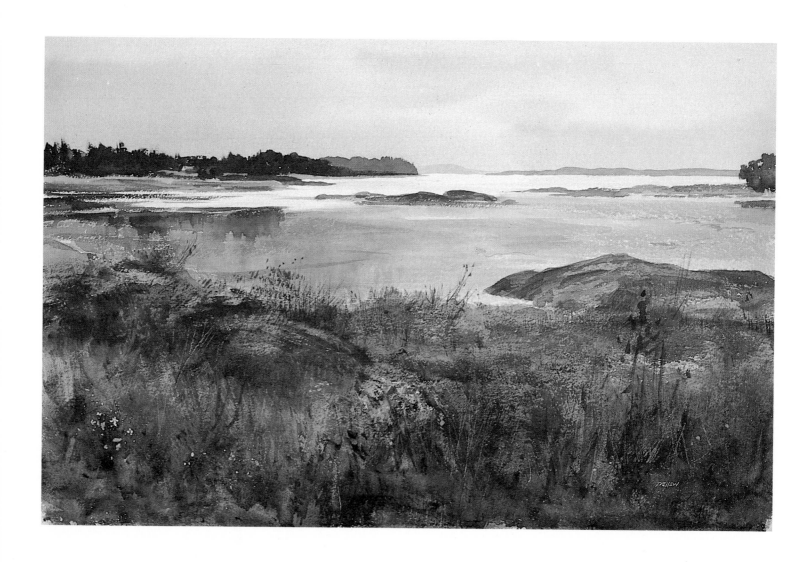

THE WAY TO DEER ISLE *(above)*
Watercolor on paper,
15 x 22 in. (38.1 x 55.9 cm)

On the coast of Maine when there is fog offshore, the ocean at the horizon can often appear as a shimmering streak of silver. I have painted several pictures along this part of the coast. It's a delightful place, especially in October, the month when I painted this one. The long fingers of the headlands with their covering of pointed firs reaching into the Atlantic, the rock ledges, and the burnt ochre of the seashore grass, all add up to an unforgettable experience. The warm-colored foreground, the cool distant color, and the long horizontal lines of the headlands, together create an illusion of great depth and recession. It's almost impossible to make a bad composition here. Notice the textural variety in my foreground. There's a lot of drybrush in this part of the picture. The dark drybrush was painted over warm undertones of burnt and raw siennas, yellow ochre, and cadmium orange. For the wild flowers in the lower left I used opaque white.

OLD WORKINGS *(right)*
Watercolor on illustration board,
10 x 14 in (25.4 x 35.6 cm)

At Russell's Gulch we found evidence of the old mining days on the mountainsides. Up on the hill among the aspens there was also an old cemetery where many of the stones bore Cornish names. In the last century hundreds of miners from Cornwall migrated to Colorado. With them they brought their religion, their love of singing, and their native dishes. In this painting I kept the sky and mountain range in order not to have competition with the busy foreground. I could see a lot of detail on the mountains but eliminated it for that reason. I often tell students not to paint each part of a picture with equal emphasis. In the right foreground there is some spatter and on the bank at the left, some stipple. The snow on the peaks is white paper.

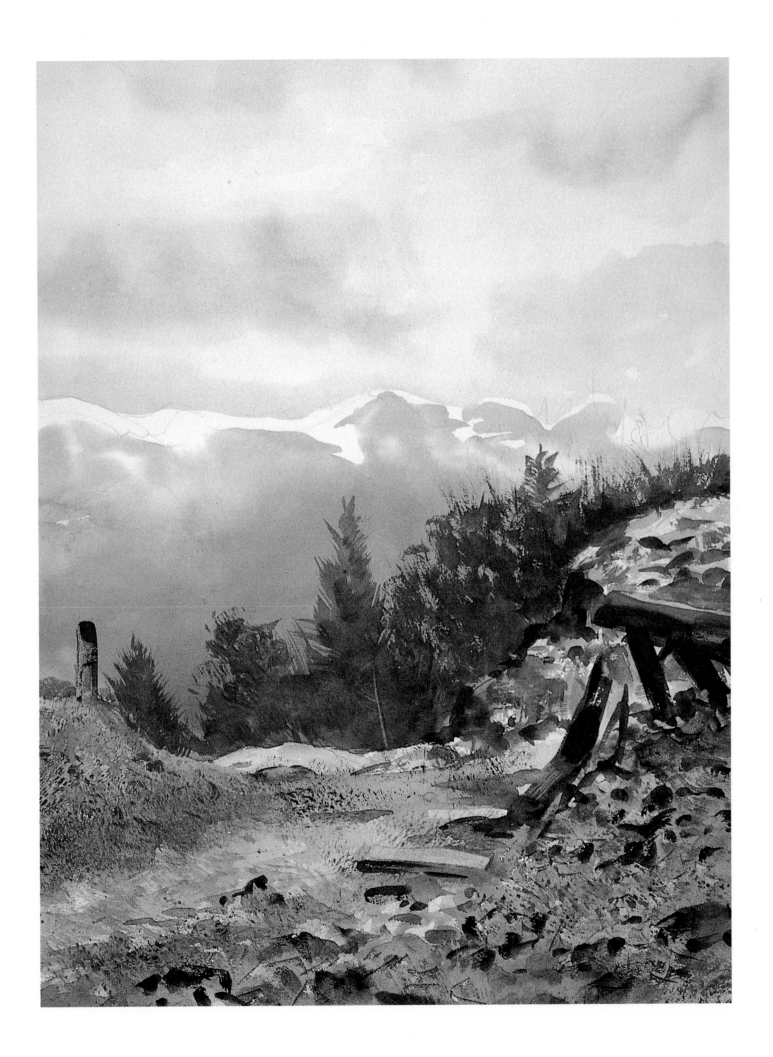

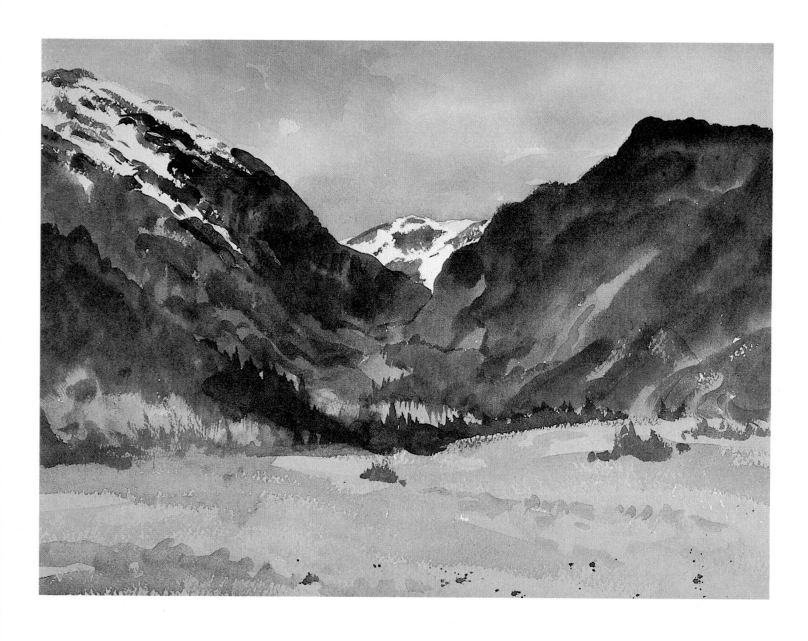

ABOVE EMPIRE
Watercolor on cold-pressed paper,
9 x 12 in. (22.9 x 30.5 cm)

It had rained in the morning but brightened a little around noon. I was with a large group of students in Georgetown, Colorado. Someone said, "Let's go over to Empire." A few brave souls not afraid of the showers went with me in the van. We parked in this mountain meadow. It was a day for fast painting, a good thing for outdoor painters to learn. I was putting the final strokes on my small watercolor when the skies opened up and down it came. There was a hasty retreat for the shelter of the van where we finished our pictures. My gray sky tones are mixtures of burnt umber and phthalo blue painted into a pale wash of yellow ochre, wet into wet. The darks of the mountains are mixtures of burnt umber, raw sienna, and phthalo blue. The foreground is yellow ochre toned with some of the dirty gray left on the palette. The snow on the peaks is carefully saved white paper.

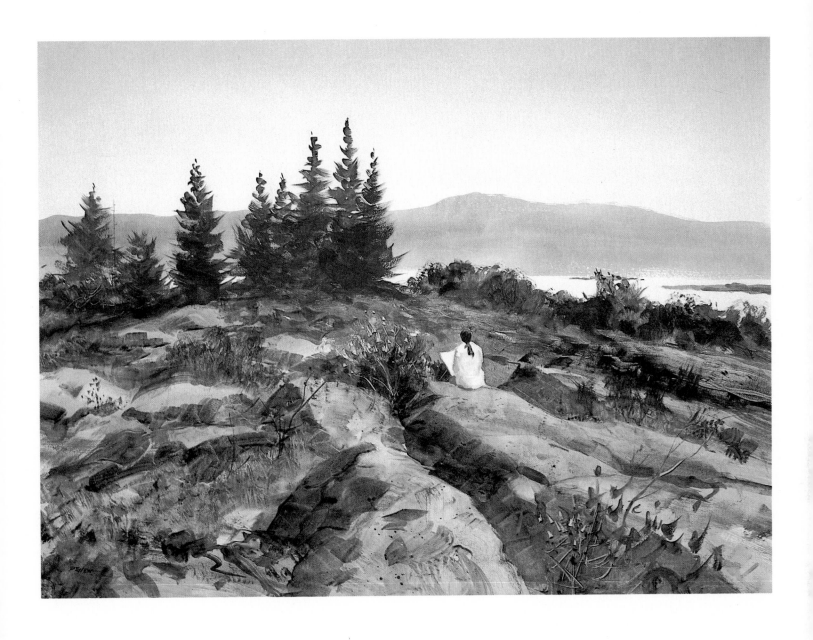

BETTY SKETCHING
Acrylic watercolor on illustration board,
22 x 30 in. (55.9 x 76.20 cm)

Acrylic can be used in many ways. Here it has been used in a watercolor technique. The sky in the picture is the only place where a sable brush was used. All the rest was painted with bristle brushes. The sky was first given a very pale yellow ochre wash into which I painted, while it was still wet, another very pale wash—this time of phthalo blue—along the top edge. The distant land is a flat gray obtained with a mixture of phthalo blue and cadmium red light. The water is pure white paper. The time of the painting is a day in late September, so I used a number of warm colors in the foreground. The dark greens of the trees and bushes are mixtures of raw sienna, burnt sienna, and phthalo blue put down at their full value and not worked over. The grassy parts of the foreground are combinations of yellow ochre, raw sienna, burnt sienna, burnt umber, and cadmium orange. The gray rocks are a mixture of burnt umber and phthalo blue. I scraped their tops with the flat edge of a razor blade. There's a little opaque white on the girl's shirt. The place is Ocean Point, Maine.

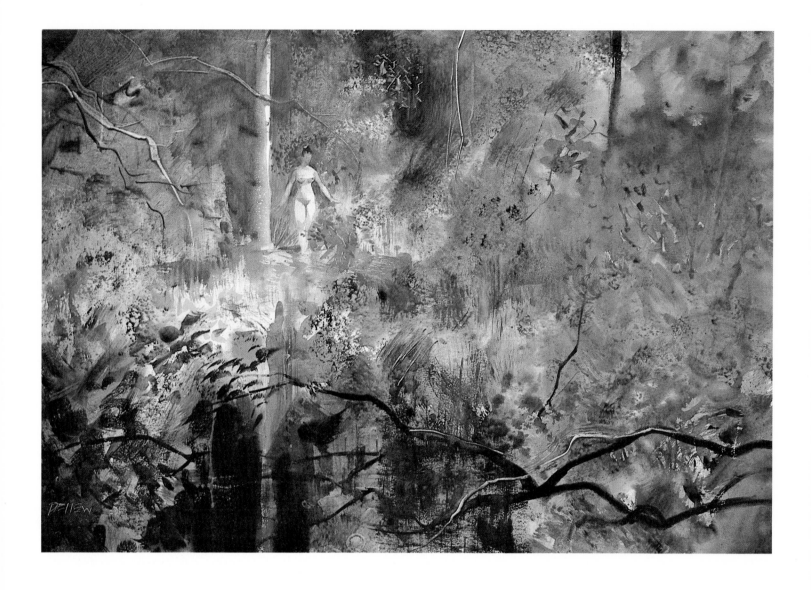

THE HIDDEN POOL *(above)*
Watercolor on paper,
15 x 22 in. (38.1 x 55.9 cm)

This work is one of my improvisations. I enjoy doing them as a change from my more traditional outdoor painting. They are stuff to dream on. I think this one has a dreamlike quality. Call it poetic, call it abstract, call it what you will—I call it a painting. It is playing with textures, shapes, and colors with only my visual memory as a guide. I thought the all-over busy quality of the painting needed a focal point; so I invented the lady. I'm glad I did. The picture is much better since she walked into it. The technique here is much the same as that used in my other improvisations— color washes floated on wet paper and allowed to blend together—lights scratched with fingernail in damp paint and also blotted and wiped out with sponge and paper towel. The darkest darks were put in last when the paper was almost dry. The colors used are cadmium red light, burnt sienna, raw sienna, cadmium yellow, cadmium orange, and ivory black.

COPELAND LAKE *(right)*
Watercolor on illustration board,
10 x 14 in. (25.4 x 35.6 cm)

Painting a landscape at an altitude of 8,200 feet is certainly a change of pace for a painter who has lived all his life at sea level. Copeland Lake, in beautiful Colorado, is a short walk down the road from Wild Basin Lodge where I stayed with a group of students. For the first wash I used a little yellow ochre with lots of water over the entire surface. Very diluted phthalo blue and cadmium red light went into this, and were allowed to blend with the first wet wash. The mountain and its reflection were a mixture of cadmium red and phthalo blue. The snow on the peak is the sky color, but, being surrounded by a darker tone, it appears lighter than the sky. The trees and their reflections are mixtures of raw sienna, phthalo blue, and alizarin crimson painted wet into wet. The foreground is composed of a wash of cadmium red light which was allowed to dry. A wash of phthalo blue toned down with a little leftover red was painted over this. The bold brushwork and spatter are darker mixtures of the same two colors.

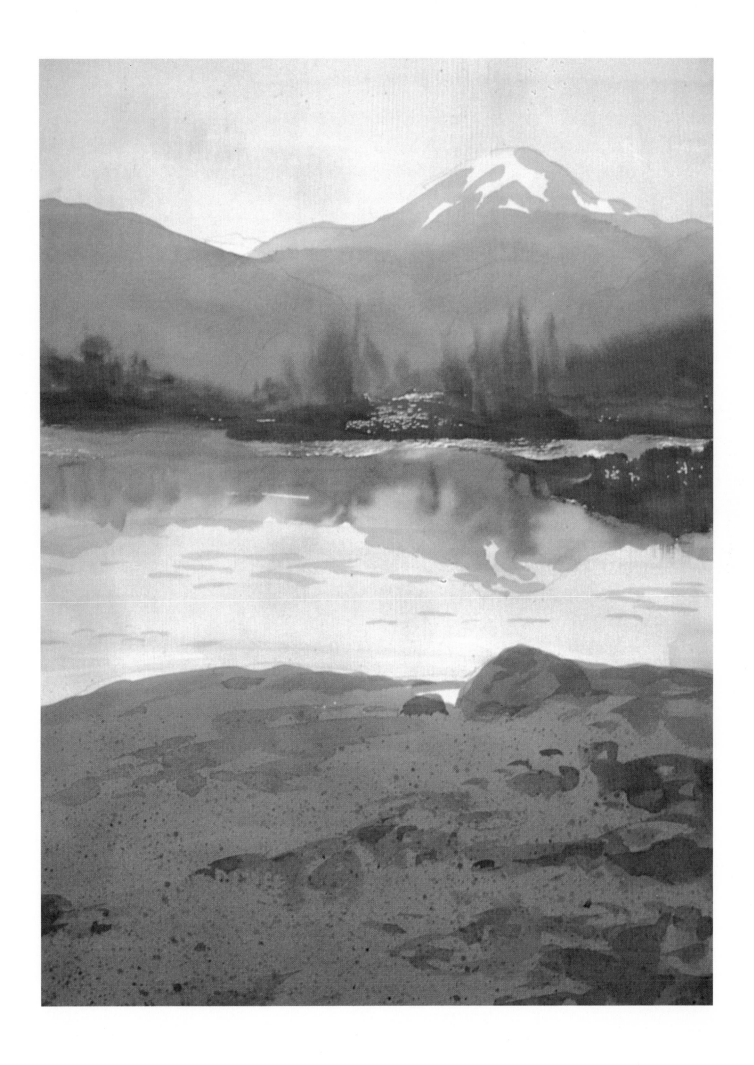

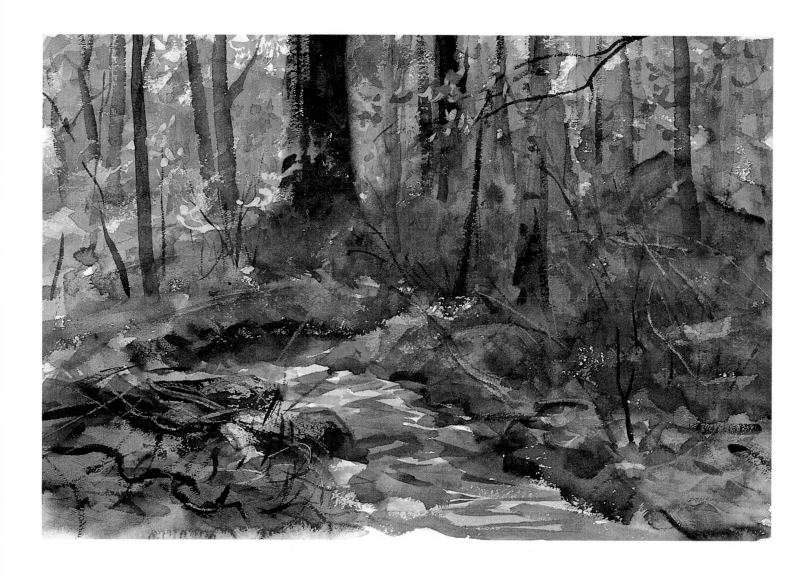

THE LITTLE BROOK
Watercolor on paper,
15 x 22 in. (38.1 x 55.9 cm)

My woodland scenes, in fact, all my outdoor watercolors, are painted directly on dry paper. This was the method used by Winslow Homer and John Singer Sargent. I know there are painters who say watercolor should always be painted on presoaked paper. Well, I do that sometimes—but in the studio. I see no sense in doing it on location. Another thing I do that the old-timers don't like is working with the paper held upright on the easel. I think it's a mistake to get so set in your ways that you think your way is the only way. Try them all, I say. This picture is of the little stream that runs through our woods. It's a summer picture. Some painters don't care to paint the summer woods. They say it's too green. That has never stopped me. Here's a tip on painting the woods: try to have one dominant tree, one that's larger than the rest.

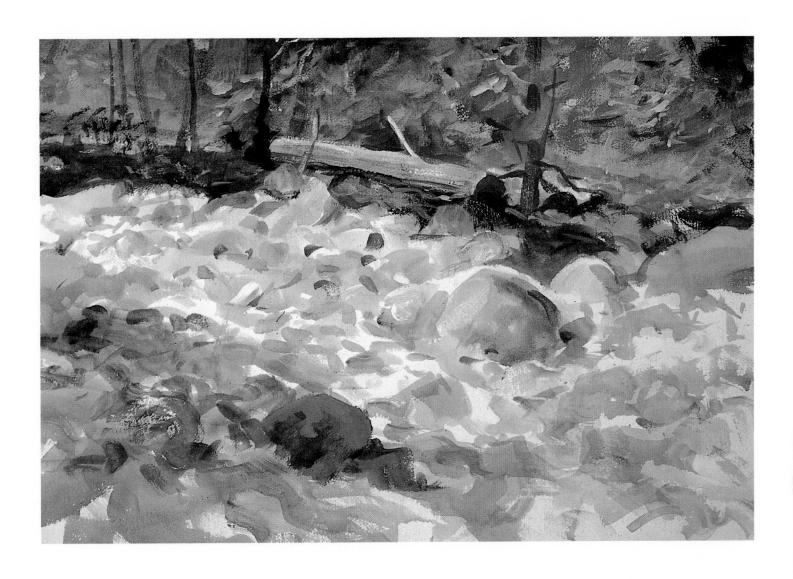

MORNING, OAK CREEK
Acrylic watercolor on paper,
15 x 22 in. (38.1 x 55.9 cm)

The watercolor *Up from the Beach*, reproduced in my book *Painting Maritime Landscapes*, was painted at an earlier date, in the same spot as this painting. There's quite a difference in them, however. In the two-year interim between the two versions, flash floods had rushed through the canyon. Some of the trees that appear in my first version had disappeared and the rocks were rearranged. However, the big log was still there. I had been painting an acrylic demo in an oil technique for a class. Thinking it might be fun to do my two-year-old subject again, I took a half sheet of cold-pressed paper and a couple of oil painter's bristle brushes, and with a can of creek water rapidly painted the version above. I suggested the rocks in a bravura shorthand, leaving white paper for their lightest lights. I used only the paint left over from the demonstration, telling myself that when it was used up I would quit—and that's what I did. The colors used are cadmium red light, burnt and raw siennas, phthalo blue, and yellow ochre.

OCTOBER
Acrylic on Upson board, acrylic gesso ground,
24 x 28 in. (60.96 x 71.12 cm)

This picture was done in casein and acrylic as a demonstration for the National Society of Painters at the National Academy Galleries in New York. It is a favorite subject with me—a single figure, usually my wife, emerging from the woods and carrying wild flowers or autumn leaves. For all parts except the figure I used two house painter's brushes which enabled me to finish the picture in one hour.

Amateurs often go astray when doing a small figure in a landscape because they tighten up, making it a separate little project. These figure should be painted in the same spirit and technique as the rest of the picture. Notice how simply I have painted the figure. There is just enough light and shade to give it solidity and no details such as features, fingers, or feet. The important thing is to get the proportions correct. If the gesture, the action, is established, no details are needed. The warm color scheme is complemented by the cool blue of the figure's slacks. Because the white shirt is the lightest light, the lady becomes the single dominant point of interest.

THE OLD ROAD
Acrylic on illustration board,
20 x 24 in. (50.8 x 60.96 cm)
Collection Mr. and Mrs. George Gilbert.

Parts of these old forgotten roads can be found in each of the New England states. They usually lead nowhere, having been cut off from their destination by the building of a new thruway or turnpike. They were designed for horse and wagon travel and their many curves are more pleasing than our modern straight lines. This one, about a block long, runs off my road to a busy highway. It's too narrow for cars, has no houses on it, and serves no purpose. It's just a leftover piece of old road. This picture was painted on a cold March day. It was done directly with brushes, without any preliminary pencil drawing. When we paint on location, I often tell students they should learn to draw with the brush as they paint. When working outdoors, an impression is all there is time for. The sun won't stand still. If the painting can't be finished in two hours, come back the next day at the same time and continue. That's what the 19th century *plein-air* painters did. So copy their method or paint an impression. The painting time for this picture was one hour and thirty minutes.

BIBLIOGRAPHY

Here are a dozen books on watercolor history and technique that I've enjoyed.

Early English Watercolour by C. E. Hughes, Ernest Benn Ltd., London, 1950.

English Watercolour Painters by H. J. Paris, William Collins, London, 1945.

English Watercolours, Turner, Girtin, Cotman, Constable and Bonington. With an introduction by Laurence Binyon. Oxford University Press, London, 1949.

A History of British Watercolour Painting by H. M. Cundall, Charles Scribner's Sons, New York, 1929.

Winslow Homer Watercolors by Donelson F. Hoopes, Watson-Guptill Publications, New York, 1969.

The Life and Art of Thomas Collier, R.I. by Adrian Bury, F. Lewis Ltd., London, 1944.

More Than Shadows, A Biography of W. Russell Flint by Arnold Palmer, The Studio Ltd., London, 1944.

XIXth Century Drawings and Watercolors by Jean Selz, Crown Publishers, New York, 1968.

100 Watercolor Techniques by Norman Kent, Watson-Guptill Publications, New York, 1968.

Two Centuries of British Watercolour Painting by Adrian Bury, George Newnes, Ltd., London, 1950.

Turner Watercolours by Martin Butlin, Watson-Guptill Publications, New York, 1968.

Watercolour Sketching Out-of-Doors by Norman Wilkinson, Sir Isaac Pitman and Sons, Ltd., London, 1953.

William Callow: An Autobiography edited by H. M. Cundall, Adam and Charles Black, London, 1908.

INDEX

Edited by Dorothy Spencer
Designed by Bob Fillie
Set in 12 Point Melior

John C. Pellew is one of America's best known contemporary artists—a versatile master of many painting mediums, including watercolor, oil, and acrylic. He has had many one-man shows including three at the Contemporary Arts Gallery in New York; two at the Grand Central Galleries in New York; and one at the Baker Gallery, Lubbock, Texas. He was Associate Art Director for *Collier's* Magazine for thirteen years; has taught figure painting at the National Academy in New York; was on the staff of the Famous Artists School in Westport, Connecticut; and has been a workshop instructor with Painting Holidays for the past ten years. At present, he is on the faculty of the Silvermine Guild, New Canaan, Connecticut.

His awards include the Allied Artists Gold Medal for Watercolor, 1951; Gold Medal for Watercolor, Hudson Valley Annual, 1954; Marine Painting Award, Connecticut Watercolor Society, 1958; The Adolph and Clara Orbig Award, and The Henry W. Ranger Purchase Award, National Academy, New York, 1961; Butler Award, American Watercolor Society, New York, 1964; and the Syndicate Magazine Gold Medal, Allied Artists of America, 1967.

His paintings hang in the Metropolitan Museum of Art, New York; The Brooklyn Museum, Brooklyn, New York; The Unio Cultural, Sao Paulo, Brazil: The Georgia Museum of Fine Arts, Athens, Georgia; The Butler Institute of American Art, Youngstown, Ohio; The Reading Art Gallery, Reading, Pennsylvania; The New Britain Museum of American Art, New Britain, Connecticut; The Norfolk Museum of Fine Arts, Norfolk, Virginia; The W. B. Connor Foundation, Danbury, Connecticut; Columbia University, New York; Adelphi College, New York; and the University of Maine.

Mr. Pellew is a member of the American Watercolor Society and has served three terms on the Council of the National Academy. He resides in Norwalk, Connecticut.

JOHN PELLEW PAINTS WATERCOLORS

After forty-five years of painting, John Pellew, one of the best-known contemporary American artists, a versatile painter in watercolor, oil and acrylic, writes a book on how he personally paints watercolor. In this book, Pellew invites the reader into his studio, to listen to his comments on life as an artist, to watch him demonstrate the variety of techniques he uses, and to gather valuable tips from a master of the brush.

The author begins with a brief look into his personal life, sharing stories of his youth in Cornwall, England, where many of that country's most distinguished artists spent their summers. Pellew tells of some of the artists of the period who influenced him and whom he still admires and uses as teaching references. He tells of his family's move to America when he was in his teens; the new friends he made; his first job in the art world; his first exhibition and sale.

Then he describes his studio, taking the reader on a personally guided tour, explaining its setup, and the materials and methods he uses for painting in watercolor. He explains how he develops his pictorial ideas; his use of a camera to record ideas for later development; he reveals how he paints on location and from memory in his studio. He shares his painting secrets with the reader—demonstrating how he corrects a watercolor and how he makes use of just his fingernails to accomplish many stunning effects. Throughout, Pellew philosophizes about his life as an artist and its rewards.

He then paints six step-by-step demonstrations, every step illustrated full-page and in color. You are taken on location to the desert, a rocky beach on the coast of Maine, a mountain stream, a salt marsh, and into the artist's studio where, from memory, he paints the woods in autumn and the woods in winter.

The book concludes with a one-man show of the artist's best work, all reproduced in full-color and one to a page, with captions explaining the hows and whys of each picture.

John Pellew Paints Watercolors is an invaluable book for anyone interested in mastering the skills of outdoor, on-location watercolor painting. The artist has written a book which will inspire everyone from beginner to expert to go outside, to look around them and to paint not only what they see but what they feel.